Art Book
Matisse

DORLING KINDERSLEY
London • New York • Sydney
www.dk.com

Contents

How to use this book

This series presents both the life and works of each artist within the cultural, social, and political context of their time. To make the books easy to consult, they are divided into three areas which are identifiable by side bands: yellow for the pages devoted to the life and works of the artist, light blue for the historical and cultural background, and pink for the analysis of major works. Each spread focuses on a specific theme, with an introductory text and several annotated illustrations. The index section is also illustrated and gives background information on key figures and the location of the artist's works.

759. 4/0123716

■ Page 2: Matisse, *Portrait of the Artist*, 1900, private collection.

1869-1905

1905-1913

The attorney's clerk becomes an artist

BACKGROUND

France during the Third Republic

■ The Dreyfus affair divided the nation: intellectuals and politicians were moved to defend the officer condemned for high treason. His acquittal, following the "J'accuse" of writer Émile Zola, signalled a victory for civilian power over the army.

T he years 1870–71 were fundamental and decisive in the history of France. The traumatic end of the empire of Napoleon III, defeated and humiliated by the Prussians at Sedan, threw the nation into chaos: the newly created Third Republic had not only to bear the burden of the peace treaty, but also had to deal with its own internal divisions. The violent repression of the Commune increased tensions between a right wing dreaming of a strong, authoritarian government, capable of "retaliation", and a left wing struggling with the Republican Block, ready to defend the rights of workers (the first unions were created between 1894 and 1895). These were years characterized by vain attempts to restore the monarchy and Bonapartism (one attempt was made by Georges Boulanger), efforts to create anarchy, scandals involving a number of corrupt politicians and financiers (such as the question of the Panama canal in 1892–93), and tensions between Catholics and anti-clerics, up to the so-called Dreyfus affair. At the same time, however, this was a period of tremendous scientific progress, acknowledged and celebrated in the Great Exhibition of 1889. The Eiffel Tower was erected for the occasion, 300 m (330 yds) high, over an area 100 m (110 yds) wide.

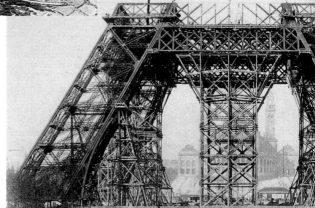

■ To commemorate the Great Exhibition of 1889 the Parisians wanted to create an extraordinary monument, which would celebrate a feat of engineering and science. The project was carried out by the engineer Gustave Eiffel.

■ The astonishing results achieved by scientific research and by associated technical progress produced an atmosphere of almost unlimited faith in science and a rejection of the spiritual tensions of the Romantics.

This was the age of positivism, expounded by Auguste Comte and linked to the evolutionary theories of Charles Darwin and Herbert Spencer and the historical materialism of Karl Marx and Friedrich Engels.

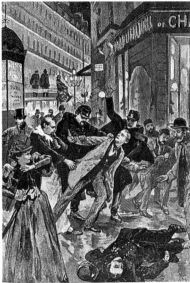

■ The defeat at Sedan in 1870 meant the end of Napoleon III's dreams of empire: three days later, on September 4, the Third Republic was declared. Paris was besieged and in January 1871 was forced to capitulate. During the Franco-German peace negotiations the people rebelled and the Commune was born, a proletariat and socialist revolution created from the bloodbath provoked by Adolphe Thiers.

■ The arrest of the anarchist Henry was one of many episodes symptomatic of the social tensions and political battles of turn-of-the-century France.

1869–1892: the attorney's clerk becomes an artist

Henri Émile Benoît Matisse was born on December 31, 1869 at Cateau-Cambrésis, where his parents ran a store selling grain and paint. He went to school in Saint-Quentin, and then to college in Paris in 1887, where he gained his *capacité*, a type of law degree. On his return to Saint-Quentin he found a position with a lawyer named Derieu, but never really settled. He later confessed that he had filled page after page of a register with lines from La Fontaine's *Fables*, without anyone noticing, convinced the work he was doing was useless. He began taking art lessons at the Quentin de la Tour school. He spent almost all of 1890 in bed, incapacitated with a stomach complaint; and it was during his convalescence that his mother gave him a paintbox. His health restored, he decorated his uncle Émile Gérard's house at Cateau-Cambrésis and practised making copies of paintings. His first original was *Still Life with Books*, which he signed reversing the letters of his name, "essita MH". At this point he decided to abandon law and to devote himself to painting: in October 1891 he was given permission to go to Paris, to study at the Académie Julian under Adolphe-William Bouguereau, arriving with a letter of introduction from a Saint-Quentin painter.

■ The birth of Henri Matisse on December 31, 1869 was registered on January 3, 1870 at the Town Hall of Cateau-Cambrésis. The note in the margin refers to his marriage to Amélie Parayre, on January 8, 1898.

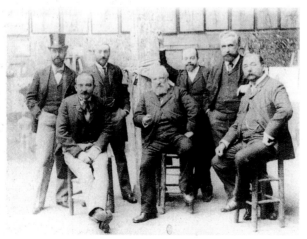

■ In Paris Matisse found the atmosphere lively and culturally very stimulating, dominated by personalities as forceful as they were combative. The defenders of tradition were vociferous in condemning the innovative work practised by the Impressionists.

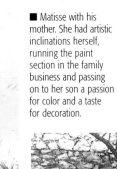

■ Matisse with his mother. She had artistic inclinations herself, running the paint section in the family business and passing on to her son a passion for color and a taste for decoration.

■ Émile Hippolyte Henri Matisse and Anna Heloïse Gérard, parents of Henri. When he went to Paris they gave him a monthly allowance of barely 100 francs, hoping to dissuade him from going.

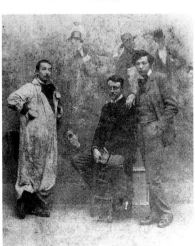

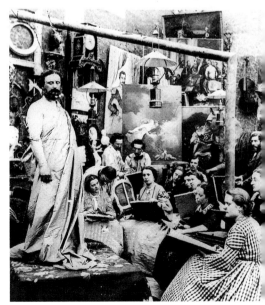

■ In this photograph of 1892, Matisse is in the center between Émile Jean and Jean Petit, friends and colleagues at the Académie Julian, a private school run by teachers from the Paris Ecole des Beaux-Arts.

■ A painter's apprenticeship was lengthy and arduous: involving hours of practice in the studio as well as in museums, studying and imitating great masters of the past, and in galleries, discussing new ideas.

1869-1905

The Schiedam Bottle

This still life, painted in 1896 and now in the
Hermitage in St Petersburg, marks a significant
stage in the artist's color development and
demonstrates a confident personality, already
aware of his own technical capabilities.

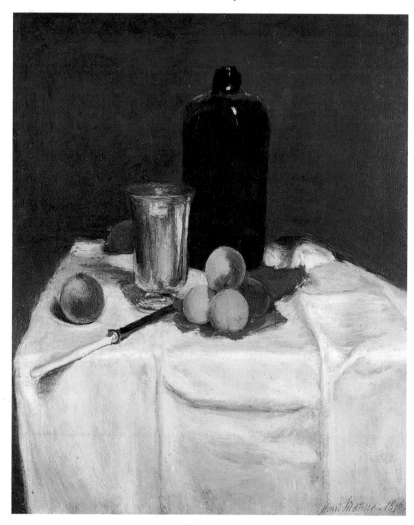

■ Matisse, *Vase and Fruit*, 1901, Hermitage, St Petersburg. As the century drew to a close the artist discovered Japanese prints, which fascinated him and provided even more encouragement in his pursuit of color and light. "At the Louvre", he wrote in 1942, "we only looked at the Japanese art, which showed us color". Here the colors are garish, with marked contrasts, with limited use of chiaroscuro and shadowing, summarily rendered.

■ Matisse, *Still Life*, 1898, sold at Galerie Beyeler, Basle. Many elements in common with the *Schiedam Bottle* are evident, such as the position of the knife, the color relationship between the bottle, the vase and the fruit, and in general, the viewing angle, as well as the placing of the light. However the format of the composition is different – here it is horizontal, there vertical.

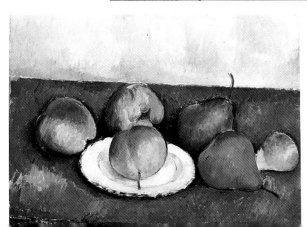

■ The work of the painter Paul Cézanne was fundamental to the artistic development of Matisse. This *Still Life* (1883–88, sold at Sotheby's, November 3, 1993), demonstrates Cézanne's capacity to create space with a few simple, well-judged touches of color, a key lesson for Matisse.

LIFE AND WORKS

1892–1897: Development as a painter

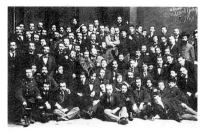

MMatisse quickly distanced himself from the teaching of the Académie Julian, which he did not find stimulating, especially after he failed to win a place at the École des Beaux-Arts. He signed up for an evening class at the École des Arts Décoratifs, and took a course in descriptive geometry, with the aim of becoming an art teacher. At the end of 1892 the young man was brought to the attention of Gustave Moreau, who invited him to join him, even though he was not an official pupil, at least until he had passed the entrance exam for the École. Moreau's teaching was fundamental to his pictorial development and enabled him to make the quality leap necessary for him to become a fully fledged artist. Matisse spent many hours at the Louvre, copying masterpieces, especially the Flemish painters of the 16th and 17th centuries. On April 1, 1895 he was finally admitted to the École des Beaux-Arts and over the next two years he successfully exhibited four paintings at the Salon de la Société Nationale.

■ In this period of intense study Matisse formed many friendships among his numerous classmates: these were the people who sympathized with him when he was rejected by the École des Beaux-Arts and who encouraged him to carry on and not to lose heart.

■ Matisse is seen here in a photograph taken by his friend Émile Wéry in 1896, during a visit to Belle-Île, in Brittany. "At the time all I had on my palette was bistre and earthy colors, whereas Wéry had an Impressionist palette".

■ This drawing (Musée Matisse, Nice) is one of a series of self-portraits produced between 1898 and 1900. The style, especially the interplay of light and shade, is reminiscent of the self portraits of Rembrandt, his source of inspiration as an engraver.

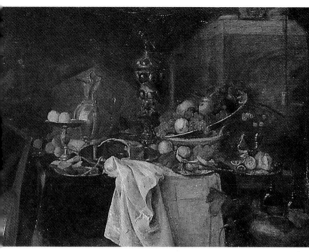

■ Matisse, copy of *La Desserte* by Davidsz. de Heem, 1893, Musée Matisse, Nice. The work has strong links with northern painting, which Matisse had studied as a young man, visiting the museums of northern France, in places such as Lille. The work is technically complex, a task Matisse regarded as a challenge, and in which he triumphantly succeeded.

■ Matisse, *Still Life after Jan Davidsz. de Heem's "La Desserte"*, 1915–17, Museum of Modern Art, New York. The artist returned to and reinterpreted his copy of de Heem "according to methods of modern construction". The austere, almost monochrome, approach of the Flemish painter is refreshed and given new life by the sensual harmonies and the warm light, so loved by Matisse.

■ In 1895 and 1896 Matisse went to Brittany to paint. In this *Village in Brittany* (1896, Musée Matisse, Nice), the artist makes an effort to interpret the techniques of Corot and makes use of almost transparent shades of grey, in order to express a sense of intimate, peaceful everyday life.

The teaching of Gustave Moreau

The artist Gustave Moreau (1826–1898) represented the last of the decadent artists, continuing the romantic tradition of Delacroix. He was one of the great precursors of Symbolism, and the Surrealists found him inspirational. Between 1864 and 1869 he reached full expressive maturity, his style still infused with Classicism and strong literary elements. After 1870 his work became even more complex and flowing, sensual and mystical, blending myth, history, and religion. Stylistically the almost scientific naturalism of the detail (such as the architectural reconstructions in the background) and his notable ability as a colorist, accentuate and exalt the layout of the composition, often stamped with a delirious imagination. Without sharing his stylistic preferences, Matisse was still enthused by Moreau's tireless creative energy and by his enthusiasm. This made him, according to Rouault, one of his most brilliant and affectionate pupils, "master to everyone and the least professor-like".

■ In 1900 Matisse produced the canvas *L'Homme Nu,* which gave him the inspiration for this bronze, titled *The Serf,* clearly suggested by the famous sculpture by Auguste Rodin.

■ *Oedipus and the Sphinx* (1864, Metropolitan Museum of Art, New York) is a masterpiece by Gustave Moreau, creator of sumptuous, complex settings, with a forceful emotional impact.

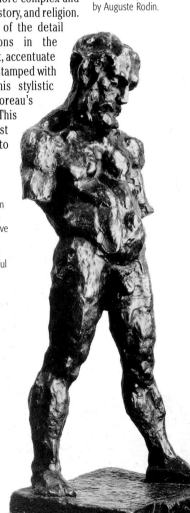

■ Matisse, *Carmelina*, 1903, Museum of Fine Arts, Boston. The artist's studies moved on to new levels and in different directions. This painting was inspired by the work of the Swiss painter, Félix Vallotton, also a pupil at the Académie Julian.

■ *Salome at the Column* (1870, Collection Lebel, Paris) is another famous painting by Gustave Moreau. The light shines evenly and uniformly, and the effect is magical, multiplied in a thousand flashes of enamel.

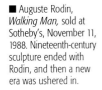

■ Auguste Rodin, *Walking Man,* sold at Sotheby's, November 11, 1988. Nineteenth-century sculpture ended with Rodin, and then a new era was ushered in.

17

1898–1900: marriage and children; visits to London, Corsica and Toulouse

Matisse with his children, in a photo from around 1909: from the left Marguerite, Pierre, Henri and Jean. The family was very close and this enabled them to survive even the most difficult times. They are the subjects of numerous portraits and often appear in charming domestic settings.

On September 3, 1894, Matisse's daughter Marguerite was born. He had been living with her mother, Caroline Joblaud, for a year. A few years later he met Amélie Parayre, a young woman from Beauzelle, near Toulouse, whom he married on January 8, 1898. On honeymoon in London, the works of Joseph Turner made a great impression on the artist. The couple returned to Paris, pausing for a few weeks before setting off for Corsica, guests of Amélie's sister, the head of a girls' school in Ajaccio. Matisse's paintings, interiors and landscapes became clearer and more luminous: his color palette was richer and closer to that of the Impressionists. In August the couple went to Beauzelle and it was here, on January 10, 1899, that their first son, Jean, was born. On their return to Paris, they settled in the flat at 19 Quai Saint-Michel, where Matisse had lived in the days of the Académie Julian. In the same year he bought several works from the art dealer Ambroise Vollard, among them *Les Trois Baigneuses* by Cézanne, which was to influence his artistic development and which he kept near him. A second son, Pierre, was born on June 13, 1900.

In Corsica Matisse painted a dozen small pictures and a few canvases, among them this *Corsican Landscape* (1898, Hermitage, St Petersburg). It was his first experience of the warm Mediterranean light which was to leave such an indelible mark on his painting.

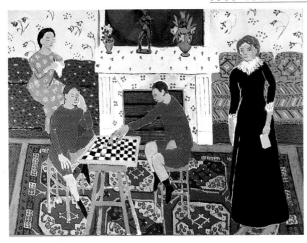

■ Matisse, *The Painter's Family,* 1911, Hermitage, St Petersburg. "My wife is intent on sewing; Pierre and Jean are playing draughts; Marguerite is standing."

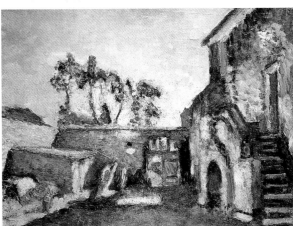

■ Matisse, *The Court-yard of the Mill*, 1898, Musée Matisse, Nice. The Corsican period marked a new approach to color, dominated by a warmer and more intense luminosity.

■ Matisse, *Notre-Dame,* sold at Christie's, May 10, 1994. Another step forward in the use of color – here the style is more energetic and decisive.

■ From his Paris apartment Matisse could see the river Seine and the cathedral of Notre Dame to the east (see the painting to the right) and to the west the Pont St-Michel, with the Louvre in the background.

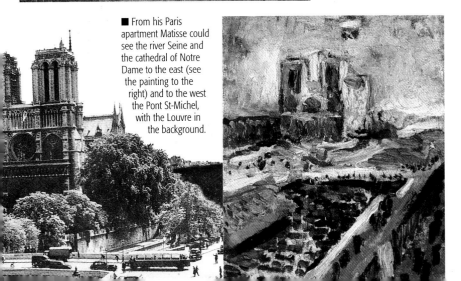

The Salons: the official art of the second half of the 19th century

From the 18th century onward the artists at the Academy exhibited their work to the public in the Grand Salon at the Louvre, initially at irregular intervals, and later annually. In time the Salon became the largest market in the world for contemporary art. For a young artist, admission to the Salon was the equivalent of entering the art world's Paradise. The 200–300 paintings on show were seen daily by crowds of people, with at least 10,000 visitors each weekday, rising to 50,000 on Sundays, registering a considerable turnover of business. The jury consisted of professors from the École des Beaux-Arts, who exerted themselves to win approval for the work of their own pupils. The reputation, and therefore the entire career of an artist, could be made or ruined, not simply according to whether paintings were included or rejected, but also as a result of the prizes awarded by the jury and the reviews of the critics in the main newspapers. The absolute rule of academic officialdom was occasionally shaken: in 1855 Courbet created his own "Realist" pavilion; and in 1863 The Impressionists set up their own rival Salon des Refusés (Salon of the Rejected). A few years later the artists Seurat and Signac created the Salon des Indépendants.

■ Fernand Bourgeat, *The Last Brushstroke,* photo of the Salon from 1894, National Gallery, Washington.

■ Honoré Daumier, *An Influential Critic Walks by*, Metropolitan Museum of Art, New York. The caricature reflected the reaction of artists to influential critics.

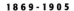

■ Albert Guillaume, *The Masterpiece*, private collection. This painting takes an ironic look at one of the aspects of Salon life: having examined thousands of paintings, the critics have finally found the "masterpiece" and are lingering to admire the painting ecstatically, groping for the appropriate terms to describe its quality.

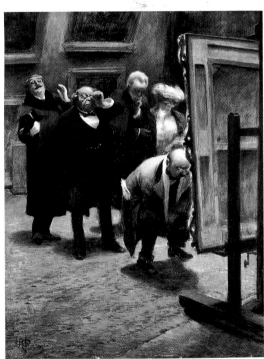

■ Edouard Joseph Dantan, *The Artist's Studio*, 1885, sold at Christie's, February 11, 1997.

■ This photo shows the final phase of the tough and lengthy selection process: the remaining works are being examined for the last time by the panel of critics before being finally accepted and admitted to the exhibition.

Interior with Harmonium

The painting *Interior with Harmonium* (c.1900, Musée Matisse, Nice) is one of his more complex and innovative works, a departure from the placid front-view landscapes he executed in Corsica and Toulouse.

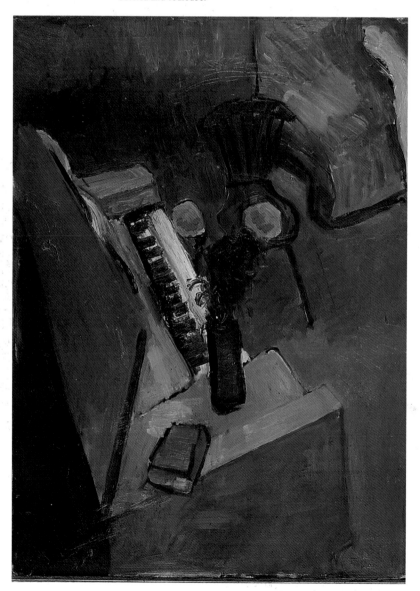

■ Painted on board, the painting reveals areas which have been repeatedly repainted and gone over again and again, as is the case with this armchair, which looks as though it has been moved during the course of painting, in order to enclose the composition. This makes the picture seem folded at the centre, almost as though the painter saw it as an open fan.

■ Matisse made use of an unusual and daring, often disorientating, angle, if you observe how the bunch of flowers appears to be in a totally unnatural position, with regard to the keyboard and the chair. The brushstrokes are energetic and decisive with strong tonal contrasts. It is noticeable how the flower on the right has been reworked to make it coincide with the chair.

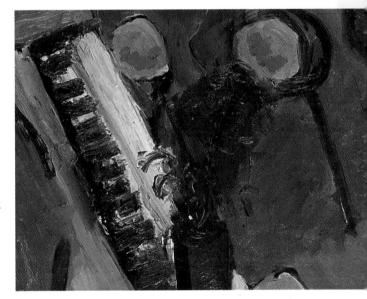

■ The book leans outwards, parallel with the lid, against which the music score is leaning, to counterbalance the thrust towards the centre given by the vase of flowers. The schematic arrangement of the composition appears to prefigure the postwar paintings. The muted harmony of the colors derives from the paintings of Cézanne, which Matisse had seen at Vollard's gallery, while the overhead viewing point can be found in other paintings by Van Gogh and Gauguin, or again in certain Japanese prints.

1901–1904: Friendship with Marquet, Derain, and Vlaminck; the first shows

The early years of the century were difficult ones for the Matisse family. After the death of Moreau, in 1898, his pupils were no longer able to make use of space at the Ecole. Distanced from the official Salons, Matisse exhibited in the Salon des Indépendants, but few paintings were sold and his father threatened to withdraw his small monthly cheque. To make a living he agreed to take on a commission, along with Marquet, to decorate the Grand Palais for the Great Exhibition of 1900, but he developed bronchitis and had to spend the winter in Switzerland, on Lake Geneva. In 1901 he met Maurice de Vlaminck and André Derain at the studio of Eugène Carrière, artists with whom he had much in common. Another important meeting was with the gallery owner Berthe Weill, who included him in a general show, with Marquet and four other ex-pupils of Moreau: Matisse sold nothing but was noticed and met other artists such as Puy, Manguin, and Camoin. In 1903 he showed two paintings at the first Salon d'Automne and the following year he held his first personal show at the gallery of Ambroise Vollard. The show did not make much money, but it did result in Matisse becoming better known.

■ Maurice de Vlaminck, *Portrait of Derain,* 1905, private collection. Derain and Vlaminck met in 1900 and went on to share a studio on the island of Chatou. They published illustrated books and shared a passion for primitive art.

■ André Derain, *Portrait of Vlaminck,* 1905, private collection. Vlaminck, allergic to all forms of teaching, was self-taught, proud of his own improvisation and an enthusiastic admirer of Van Gogh.

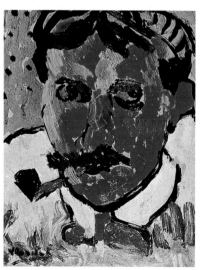

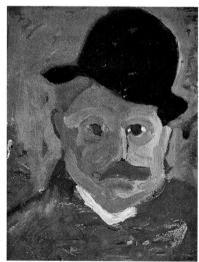

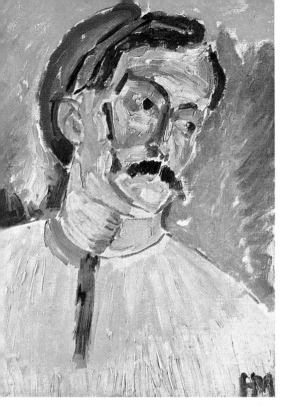

■ Matisse, *André Derain,* 1905, Tate Gallery, London. Matisse presented Derain to Vollard and introduced him to the art market. The two felt a bond of strong mutual admiration and each desired to emulate the other.

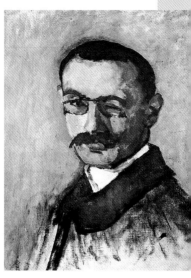

■ Albert Marquet, *Self Portrait,* 1904, Musée des Beaux-Arts, Bordeaux. Marquet was Matisse's oldest friend. They met in 1892, when they took lodgings in the same building; they worked together even though each retained his own style.

■ André Derain, *Portrait of Matisse,* 1905, Tate Gallery, London. Unlike his friends, Matisse had already acquired a serious, polite air, which, from the time when he worked at the Petit Palais, earned him the nickname of "professor".

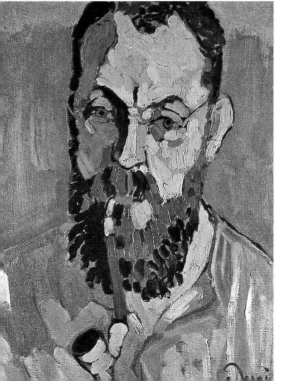

1869-1905

The Divisionism
of Seurat and Signac

■ Paul Signac, *Concarneau,* private collection. Signac met Seurat when he founded the Salon des Artistes Indépendants; together they carried out research that led to Divisionist theory, of which Signac was the major theorist.

Matisse spent the summer of 1904 at Saint-Tropez, studying the Mediterranean light. He stayed near Paul Signac's villa, La Hune, and not far from Le Lavandou, where Henri-Edmond Cross was staying, both followers of Georges Seurat. Here he was able to explore in greater depth Divisionist theories about the breaking down of color. He became fascinated by the technique, and applied himself with enthusiasm. In fact, he had already seen and admired the works of Seurat and he had been studying the theories published since the beginning of 1800, but it was only now that he felt at home with the style and appropriated it for himself. Based on optical studies, relaunched by the Positivists, Pointillism was more than a simple technique for its followers, and it was pursued as a very real vision. It had a tremendous influence on Van Gogh and Gauguin, and it created the fundamental premises for the birth of Fauvism; it fascinated the Cubists, the Expressionists and the Surrealists, and later, the exponents of American Pop Art.

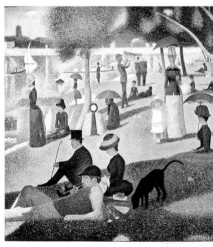

■ Georges Seurat, *A Sunday afternoon on the Île de la Grande Jatte,* 1884–86, Art Institute of Chicago. From the moment when the painting was exhibited, in May 1886, it was regarded as the manifesto of Pointillism, a model of the new technique, and a demonstrative declaration of Seurat's efforts to overcome the poetry of Impressionism. It is much more than that in reality: it is also a historical document, a faithful, objective picture of French society at the end of the century.

■ This is one of a large number of preparatory studies for the *Grande Jatte* (1884–85, Berggruen collection, Geneva) on which Seurat worked for nearly two years.

■ Paul Signac, *the Pine at Bertrard, 1909*, Pushkin Museum, Moscow. In 1899 Signac published *D'Eugène Delacroix au néo-impressionisme*, which justified Divisionist theories with scientific and stylistic motivation, re-examining the work on color carried out by Delacroix, exploring it in greater depth.

27

"Luxe, Calme et Volupté"

Matisse, *Luxe, Calme et Volupté*, 1904, Musée d'Orsay, Paris. The painting owes its title to lines by the French poet Baudelaire, in *L'Invitation au Voyage*: "Là tout n'est qu'ordre et beauté/Luxe, calme et volupté".

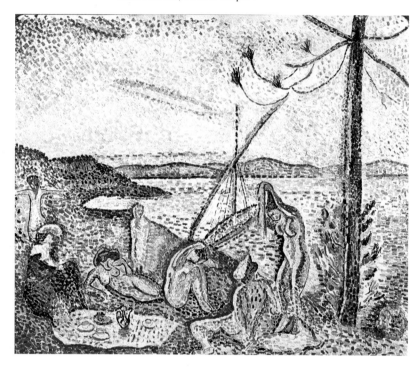

■ Presented with success at the Salon des Indépendants in the spring of 1905, this painting immediately appealed to Signac, who judged it an excellent study of his theories. In September he bought the picture and it was placed with pride in the dining room of La Hune at Saint-Tropez, where he was to remain until 1943. The painting was not shown again in public until 1950.

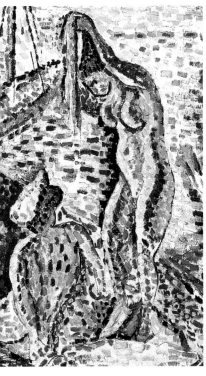

While obeying the dictates of the Divisionist style, Matisse was not rigorous and systematic, as the theories of Signac required, but let himself escape. In this detail, the sinuous and sensual lines are clearly echoes of the *Trois Baigneuses* by Cézanne, a constant source of inspiration.

The woman in *Woman with a Parasol* (1905, Musée Matisse, Nice), is in fact Amélie Matisse, at the bay of Collioure. She is shown carrying a parasol and her head is tilted towards the book in her hand. It is very lightly drawn in ink, with scattered touches of color standing out against the white background.

Matisse, *The Port of Abail*, 1905, private collection. This was the last painting to be faithful to Divisionism. It was executed in the autumn of 1905, after he had produced his first Fauvist works. Painted on a grand scale, this was a last attempt to return to a technique which had inspired great enthusiasm and proved an equal disappointment. It is meticulously drawn, with extremely precise use of color, but the overall effect is rather static.

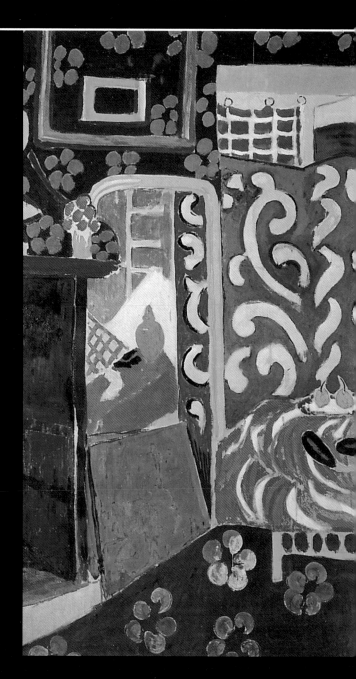

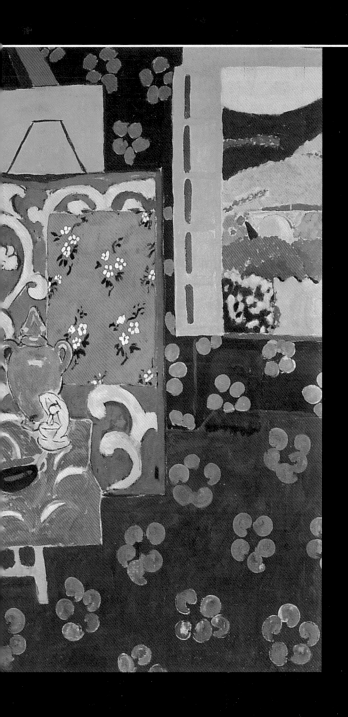

1905-1913

The Belle Époque

Life in France at the end of the 19th century has been compared by many to the grand salons of the Titanic: passengers dancing and enjoying themselves, unaware of the tragic fate in store. The new century seemed to bring a wave of optimism and faith in the future. Colonial conquests meant access to an abundance of cheap raw materials. Industry was working at full capacity, with enormous profit margins. In the three decades prior to World War I, Paris became a cultural centre driven by incredible creative forces, from architecture to the decorative arts, from art to theatre and music. This was the Paris of Renoir and Boldini, Mallarmé and Proust, Ravel and Puccini, Lalique and Toulouse-Lautrec. The city filled with cabarets, theatres, and dance halls, like the new Opéra, completed in 1875, the Théâtre du Vaudeville, the Grand Café or the Café Restaurant Américain. Ladies would parade new clothes along the boulevards, while gentlemen discussed business at the Casino de Paris or the Moulin Rouge.

■ Jean André Rixens, *Dance at the Moulin Rouge,* sold at Sotheby's, May 23, 1997. First opened in 1889, the Moulin Rouge was the most famous locale of the age, the haunt of high society celebrated in the paintings of Toulouse-Lautrec.

■ One of the valuable glass pieces created by René Lalique (1860–1945), embellished with elegant, richly colored floral decorations.

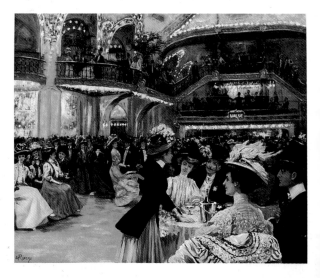

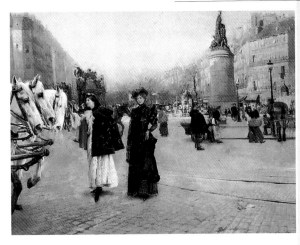

■ Laureano Barrau, *Along the Boulevards*, private collection. This is the Place de Clichy, on the border between the districts of Batignolles and Montmartre.

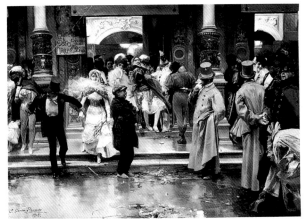

■ José Garcia Ramos, *Coming out of the Theatre*, private collection. The occasion was a performance of the famous *Baile de Mascaras*, the most important and eagerly anticipated event in the entire Parisian theatre season.

■ Léon Joseph Voirin, *The Boulevards of Paris*, sold at Sotheby's, May 23, 1997.

Light ... but also shade

Today the Eiffel Tower, the Grand Palais, the Petit Palais and other buildings in *art nouveau* style form a tangible reminder of the optimism of a perhaps never-to-be-repeated epoch. Yet the gilded, gleaming world, the sophisticated and luxurious life, belong more to literature and art than to historical reality. Unresolved social problems, the workers' struggles, political scandals, and the failure to appease monarchist aspirations disrupted those years and resulted in World War I.

Collioure

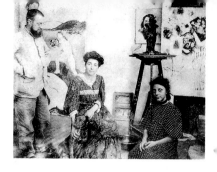

Collioure lies on the coast of southern France a few kilometres from Portbou and the Spanish border, not far from Banyuls, where the sculptor Aristide Maillol lived, and about 30 kilometres (19 miles) east of Céret, a small hill town which was to become, a few years later, the "summer capital" of Cubism. After a brief exploratory visit at the end of 1904, Matisse decided to spend the summer there, together with his family and his friend Derain. He loved the quiet, peaceful atmosphere of the small fishing village, and in later years was to spend more and more time there. The summer of 1905 marked a radical stage in the development of his painting and yielded the first Fauvist works. "Fauvism was a brief moment when we thought it was necessary to honour every color, without sacrificing a single one", wrote Matisse. In effect, the Collioure canvases show him abandoning Divisionist experimentation in favour of a new concept of light, where the colors are radiant with strong tonal contrasts and with shadow and outline almost completely absent. Among the first Fauvist works, produced in the summer of 1905, *Collioure Landscape* was a key work, later used as the background for the bucolic scene of *Bonheur de Vivre*.

■ This photograph shows Matisse in his studio at Collioure in the summer of 1907, with his wife Amélie, centre, and his daughter Marguerite on the right. Behind Matisse *Le Luxe I* can be glimpsed.

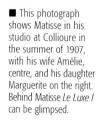

■ Matisse, *Woman on a Terrace*, 1905–06, Hermitage, St Petersburg. This was painted in the winter of 1906–7, during Matisse's third visit to Collioure.

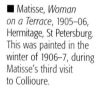

■ Matisse, *The Fisherman*, 1905, Pushkin museum, Moscow. This drawing, in which Matisse probably meant to show Derain fishing (or swimming), was presented to Shchukin.

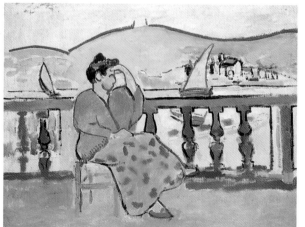

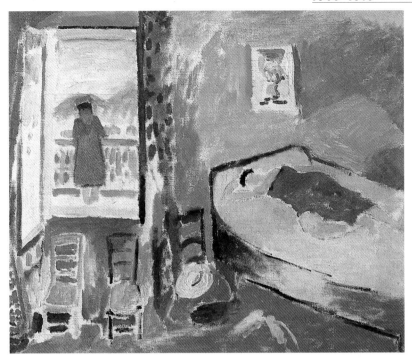

■ Matisse, *Interior at Collioure/the Siesta*, 1905, private collection, Zurich. A theme dear to the artist is beginning to emerge – the relationship between indoors and outdoors.

■ Matisse, *The Roofs of Collioure*, 1905, Hermitage, St Petersburg. This is one of the most typical of Fauvist works, a style developed that summer by Matisse and Derain.

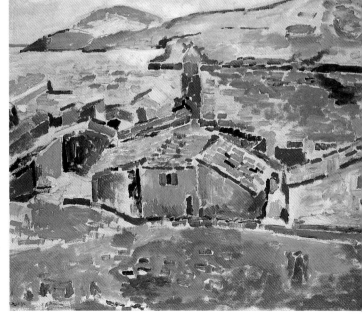

The Open Window

The Open Window, 1905, Mrs John Hay Whitney collection, New York. In this canvas Matisse brings together the landscape, the sea, and his preoccupation with still life: "the exterior and the interior merge in my consciousness".

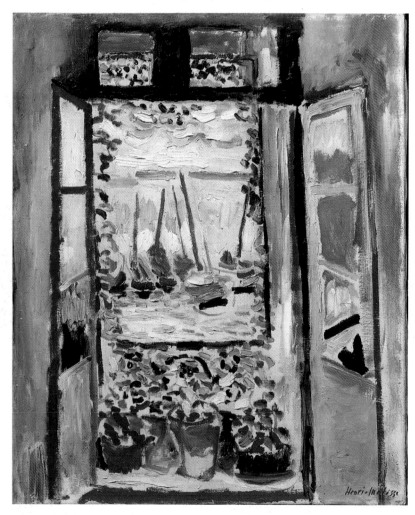

■ A photo of the window at Collioure. The theme of the open window and the relationship between interior and exterior was taken up again by Raoul Dufy in a series of paintings similar to this, carried out between 1908 and 1922, with a different color range.

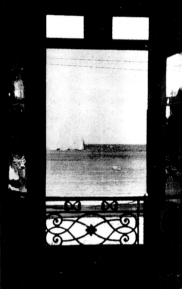

■ Through the wide open window, framed by bright green leaves, the boats of Collioure can be seen, bobbing lazily, enveloped in strong light with pink reflections in the sky as well as the sea.

■ Matisse used color with the lightness of touch typical of water-colorists, placing brushstrokes on a white background in such a way as to eliminate depth and create an effect of movement.

BACKGROUND

Post-Impressionism

At the point when Fauvism was emerging, the art world was extremely rich, overflowing with ideas. Two streams emerged from the desire to surpass Impressionism, one scientific, as in the Divisionism of Seurat and Signac, the other of a spiritual nature, the Symbolism of Moreau and Puvis de Chavannes. The most important figure, who drew a line under Impressionism and opened the way for the major movements of the 20th century, was Paul Cézanne. He was the first to theorize about a new function for painting, saying the artist should not be confined to imitating reality, but should create a new reality. Picasso and Braque followed his experiments. If Cézanne represented the "classic" soul, Gauguin and Van Gogh, who inspired most of the Expressionists, embodied the romantic myth of the rebellious artist, the misunderstood genius, solitary and in constant flight from a society unable to accept him. Alongside these, though an independent figure, was Toulouse-Lautrec, an attentive, clear-eyed observer of Parisian life.

■ Paul Gauguin, *Still Life*, 1888, Musée des Beaux-Arts, Orléans. Gauguin's pictures inspired the Nabis, a group of French artists from the second generation of Symbolists, among whom were Denis, Bonnard, Maillol, and Vallotton.

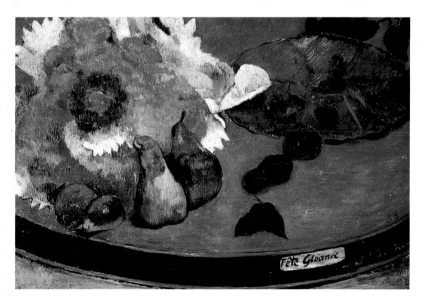

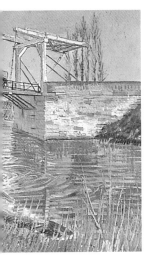

■ Vincent Van Gogh, *The Bridge at Langlois*, 1888, Rijksmuseum Kröller-Müller, Otterlo. Almost ignored in his lifetime, Van Gogh exerted an important influence on succeeding generations.

■ Cézanne, *Trois Baigneuses*, 1879–82, Musée du Petit Palais, Paris. Matisse loved this painting and kept it with him until 1936, when he gave it to the museum where it is still on display.

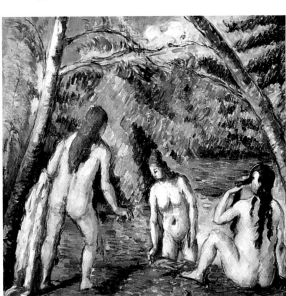

■ Henri de Toulouse-Lautrec, *At the Fernando Circus: Circus Riders*, 1887–88, Art Institute of Chicago. His paintings presented the world of spectacle in a faithful, occasionally merciless manner, showing the glamor but also the melancholy.

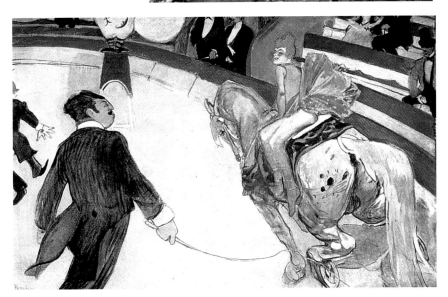

LIFE AND WORKS

1905: Salon d'Automne: "Donatello au milieu des fauves"

■ Donatello, *David*, 1409, Museo Nazionale del Bargello, Florence. When the Fauves appeared, critics were divided between praise and condemnation, some declaring them "incoherent".

At the Salon d'Automne in 1905 the paintings of Matisse, Derain, Manguin, Marquet, Puy, Valtat, Vlaminck, Friesz, and Rouault were exhibited together. There was uproar; the critics, unused to such violent and bold use of color, reacted with surprise, amazement and perplexity. The magazine *L'Illustration* devoted an entire page to them with evaluations and photos of seven paintings, among them two by Matisse, the *Open Window* and *Woman in a Hat*, which also appeared in the frontispiece. In the centre of the room where the paintings were on display was a bronze figure of a child by Albert Marquet, vaguely inspired by the sculptures of the Quattrocento. Louis Vauxcelles, a critic with the magazine *Gil Blas*, noted the stylistic contrast and coined the expression "Ah, Donatello au milieu des fauves"(Ah, Donatello set among wild beasts!). The phrase rapidly became popular and at the Salon des Indépendants in 1906 everyone referred to them as *fauves*, or wild beasts.

■ Camoin, *Portrait of Marquet*, c.1905, Musée National d'Art Moderne, Paris. Camoin met Matisse and Marquet in 1897, when he joined Gustave Moreau's studio.

■ A typical landscape by Albert Marquet (1930, private collection).

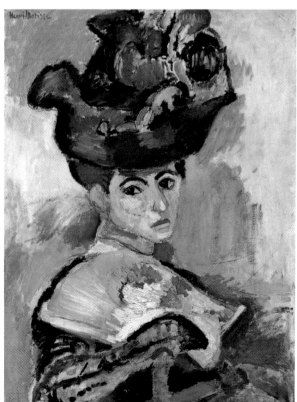

■ Maurice de Vlaminck, *Landscape with Snow,* private collection. An enthusiastic follower of Fauvism, Vlaminck was inspired by an exhibition of Van Gogh. After 1907 he was increasingly drawn to Expressionism, adopting darker colors and subjects.

■ Matisse, *Woman in a Hat,* 1905, private collection. Despite the perplexity of the judges at the Salon, and the negative comments, the painting attracted the attention of Leo and Gertrude Stein, who not only bought it, but went on to become friends of the artist and the first collectors of his work.

Fauvism: one name, many individuals

■ Georges Rouault, *Flowers*, private collection. A pupil of Moreau, Rouault was influenced by the Catholic philosopher Jacques Maritain. Conversion led to increasingly religious themes in his work.

■ Jean Puy, *Plate*, Musée National d'Art Moderne, Paris. A friend of Matisse and Derain, Puy was also influenced by the Nabis and by Gauguin.

Although they shared a name, the Fauves were not a compact, homogeneous group or, if they were, it was only for a brief period of time. The Salon d'Automne of 1905, perhaps the only time when these artists exhibited to the public in a unified manner, was a happy circumstance, based on a difficult and inevitably unstable equilibrium. Their studies, totally faithful to the expressive force of color and the use of full light without shadow, soon brought the Fauves up against other problems of structure and organization of mass, which each artist resolved in his own, completely independent way. Close collaboration and the continued exchange of ideas, opinions, and advice, only served to underline each person's individuality, which no one, rightly, wanted to give up. For almost all of the artists involved, therefore, the Fauve experience could be viewed as a moment of intense scrutiny, which was necessary to clarify its expressive, if fleeting, character. Fauvism was destined to be overtaken by other examples. Some artists, like Rouault and Jawlensky, were increasingly drawn towards German Expressionism, while others, like Puy, Derain, and Valtat, pursued their own studies in an independent way and with correspondingly different results.

■ Alexei von Jawlensky, *Inclined Head*, 1909, sold at Sotheby's, May 10, 1988. The son of an aristocratic Russian family, Jawlensky studied in Munich, where he came under the influence of the Jugendstil. His works marry the folklore and mysticism of Russian art with the colors of Van Gogh and Cézanne. From Matisse he inherited an almost extreme simplicity of form and brilliance of color.

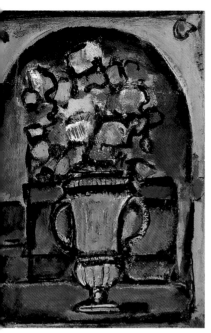

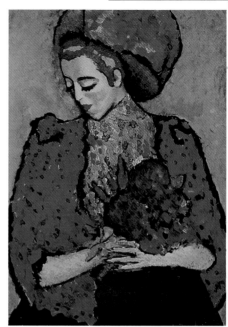

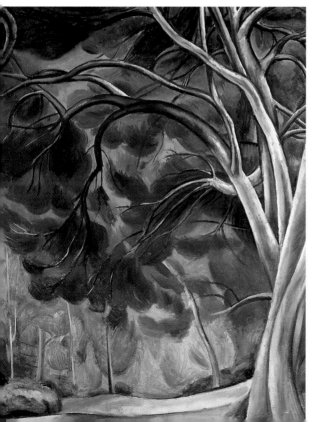

■ Alexei von Jawlensky, *Girl with Peonies,* 1909, Von der Heydt-Museum, Wuppertal. After the Fauve period, Jawlensky met Kandinsky and was attracted to the *Blauer Reiter* movement. After the war he took refuge in Switzerland, and the mystical element in his work became marked.

■ André Derain, *Trees*, c.1912, Pushkin museum, Moscow. Fauvism was a brief experience for Derain. After 1908 he returned to a more tranquil meditation on nature. And after the war he travelled to Italy and studied the Italian masters of the past (Caravaggio for one): his work subsequently became simpler and the forms more linear.

43

"Luxe"

In 1907 Matisse produced two paintings featuring the same subject – three women on the beach – but in a different style: this is *Le Luxe I*, painted in 1907 at Collioure (Musée National d'Art Moderne, Paris).

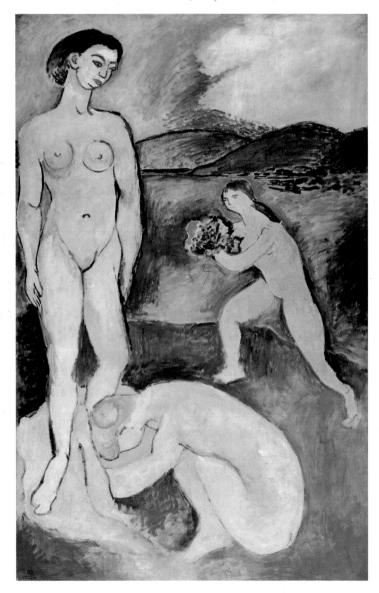

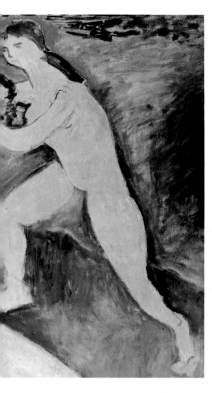

■ *Le Luxe II* was painted at the end of 1907 or in the early part of 1908 (Statens Museum for Kunst, Copenhagen). Seen with the first version, the spread of color is quite different, it is flatter and more decorative, and the figures are outlined. *Le Luxe II* was shown in 1912 in Cologne and London and then in New York, Boston, and Chicago in 1913. In 1917 it was bought by the Danish collector Rump.

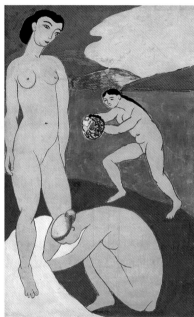

■ This is the most dynamic figure of the three, but the drawing is more approximate and the color is spread more evenly. The small bunch of flowers in her hand is outlined with great delicacy and lightness of touch.

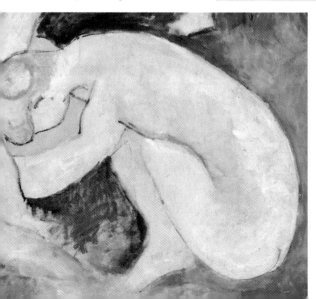

■ The symbolic significance of this scene is not at all clear and therefore neither is the function of each of the three women. The contours are just hinted at, vanishing completely at the top of the foot; the color is diffused in a single mass, dominated by the chiaroscuro, making the splash of hair color stand out.

The Le Havre group

BACKGROUND

■ Friesz, *La Ciotat*, 1907, Musée d'Art Moderne, Troyes. The influence of Gauguin is evident here, particularly in the significantly anti-naturalist color relationships and the purity of color.

■ Raoul Dufy, *Study with Fruit Bowl,* Ca' Pesaro, Museo d'Arte Moderna, Venice. Space and volume are organized with apparent simplicity: in reality Dufy studied his compositions with extreme accuracy, balancing the relationships between the objects painted.

Achille Émile Othon Friesz was born in Le Havre, northwest of Paris, in 1879. As a student, he was awarded a grant by his native city and moved to the French capital to complete his artistic education. Here he was introduced to Matisse, showing his first paintings at Berthe Weill's gallery, and joining the Fauves. He specialized in Mediterranean landscapes produced with great splashes of color, bright with strong, sunny light. Raoul Dufy was also born in Le Havre, in 1877; he too was awarded a study grant and by 1901 he was in Paris, where he alternated between the Expressionist style and Fauvism. He was a superb draughtsman and an exquisite colorist, as well as a faithful observer of the life and society of his time, which he portrayed with great delicacy. Georges Braque was born at Argenteuil in 1882, but the family soon moved to Le Havre, where they spent ten years. In 1900 he too moved to Paris: his early work followed the Impressionists, but then he converted to Fauvism, creating works of great intensity, such as *La Ciotat* and *Port d'Estaque*. His first public show was at the Salon des Indépendants in 1907, where he sold all six pictures. A few months later he rediscovered the work of Cézanne and most importantly became friends with Picasso. Cubism emerged, with Braque becoming one of its most incisive and faithful interpreters.

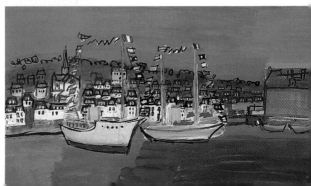

■ Raoul Dufy, *July 14 in Deville*, Pushkin museum, Moscow. Dufy's grand passion was for the cities of the south of France, in particular Nice. He loved the sea and conveyed its living energy with immense charm.

■ Braque, *Port Miou*, 1907, Civico Museo d'Arte Contemporanea, Milan. The work is suffused with a sober brilliance and conveys a sense of quiet tranquillity. While it may appear spontaneous and free, the arrangement of forms is the fruit of rigorous study, and the composition has solid depth.

1906–1907: Travel to Italy and the Salons

The most important work of art produced in 1906 was *Bonheur de Vivre* (see p. 54), a large composition full of complex symbolism. In March, Matisse presented his second one-man show, with 55 paintings, 3 sculptures, drawings, and engravings, at the Druet gallery. Back in Paris after a second summer at Collioure, Matisse and other Fauvists exhibited at the Salon d'Automne of 1906 and the Salon des Indépendants the following spring: it was a magical period for the Fauves, who were showing their best work, before moving away to pursue individual careers. In the summer of 1907 Matisse and his wife went on a long trip to Italy "for work and pleasure"; visiting Venice and Padua, where they admired the Giotto frescoes. In Florence they were the guests of the Steins in their villa at Fiesole. From this base Matisse visited Arezzo, to study Piero della Francesca, and Siena, attracted by the early Sienese painters, especially Duccio. He sent five pictures to the Salon d'Automne of 1907, including *La Musique* and the first version of *Luxe*, which he modestly called a sketch: this time the critics applauded and called him the "king of the Fauves".

■ Van Dongen, *Tea in my Studio*, 1910–14, sold at Finarte, October 10, 1992. Born in the Netherlands in 1877, he lived and worked in Paris. A cultured man, he depicted the society of his time with a critical, ironic eye.

■ Louis Valtat, *Bather*, private collection. Trained by contact with the Nabis, Valtat was one of the most faithful and genuine interpreters of Fauvism. In a way he could be regarded as a forerunner, having exhibited for the first time at the Salon des Indépendants in 1901 with Camoin and Marquet.

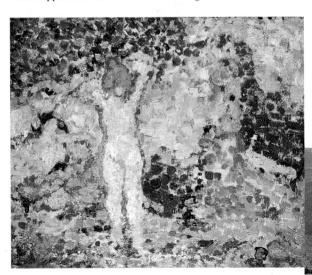

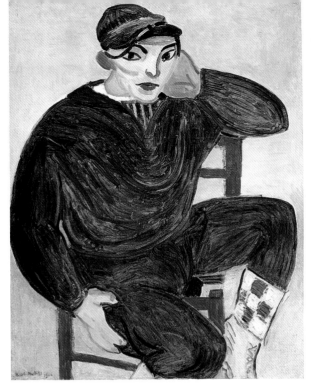

■ Matisse, *Young Sailor II*, 1906, private collection. As with *Luxe,* he produced two stylistically different versions, one rougher and uneven, this one more clearly outlined and modelled. The colors are beginning to alter, with strengthened shades, the drawing assuming greater importance and acquiring the fluidity which was to characterize his subsequent work.

■ Manguin, *Bather*, 1906, Pushkin museum, Moscow. A pupil of Moreau, Manguin was in Saint-Tropez with Matisse and Marquet in 1905 and was one of Fauvism's staunchest supporters.

■ Florence, the cathedral bell tower designed by Giotto, the great Italian artist whose work was studied and admired by Matisse on his travels in Italy.

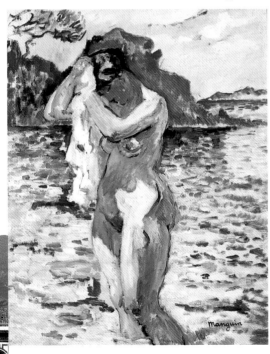

Fauvism and Expressionism

At the same time that Fauvism was developing, the first group of Expressionists was emerging at Dresden under the name of *Die Brücke* (The Bridge), which lasted from 1905 to 1913. The most important artists were Ernst Ludwig Kirchner, Emil Nolde, Karl Schmidt-Rottluff, and Max Pechstein. For some critics Expressionism represented German art's participation in Fauvism and it is possible to see many stylistic similarities. Both movements draw heavily on the work of Van Gogh and Gauguin; looking sympathetically on primitive art (African and Oceanic), as a means of surpassing and reinventing classical tradition. Both expressed almost the full range of their emotions not with drawing, but by means of pure color. However, where the French paid more attention to formal and decorative aspects, the Germans were more interested in the symbolic and emotive side. Where the French sought harmony and serenity in a portrait, in a still life, or in the bucolic atmosphere of nudes in the landscape, the Germans preferred to shock and disturb, sometimes violently. Art for them became passion, impulse, but also social and political commitment, an aspect which was totally absent from Fauvism. The Fauves dealt with their subjects from a purely anecdotal or naturalistic point of view, closer to Impressionist painting, but the Expressionists instead searched for symbolic and universal meanings.

■ Emil Nolde, *Dance around the Golden Calf*, 1910, Staatsgalerie Moderner Kunst, Munich. Emil Hansen took on the name of his birthplace, and studied at the Académie Julian in Paris. His work was emotive and expressed religious sentiments as well as anxiety. The explosive fury with which he uses color conveys a maniacal vital leap, sometimes verging on the grotesque.

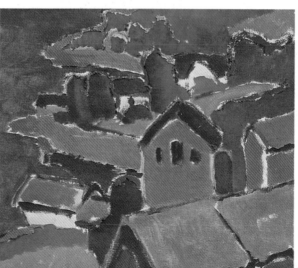

■ Karl Schmidt-Rottluff, *Lofthus*, 1911, Kunsthalle, Hamburg. One of the great exponents of Expressionism. Schmidt-Rottluff was also interested in Cubism and African art. He was fascinated by the natural world, which he experienced in a mystical sense, one moment tormented, the next joyous. He used color contrasts to create a sense of transcendency.

■ Max Pechstein, *Three Bathers*, sold at Sotheby's, June 28, 1988. Pechstein was the least Expressionist of the group and the closest to the Fauves, whether it was in choice of colors or in the prevalence of decorative values. In 1914, emulating Gauguin, he left for the South Seas, to visit New Guinea. From 1918 he worked in Germany, opposed by the Nazis, alternating between decorative works and deliberately emotive paintings and woodcuts.

■ Ernst L Kirchner, *Woman on a Blue Divan,* private collection. The undisputed key figure in Die Brücke, Kirchner was the only one to stay faithful to Expressionism throughout his long career.

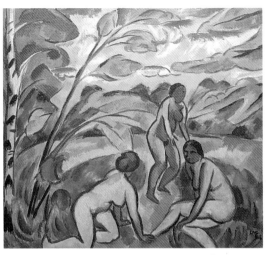

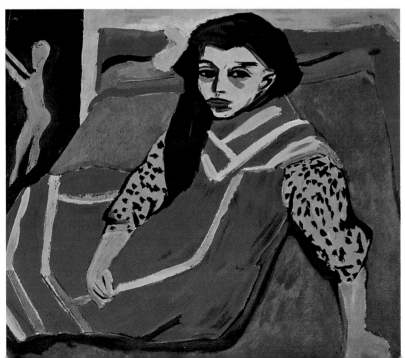

Portraits

Matisse was fascinated by portraiture and painted numerous examples. This portrait of his wife (1905, Statens Museum for Kunst, Copenhagen) was nicknamed *Green Stripe* by Michael and Sarah Stein, the first owners.

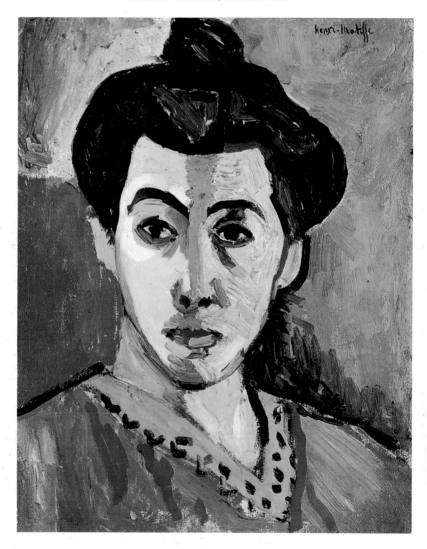

■ Matisse, *Pierre Matisse*, 1909, Pierre Matisse collection, New York. Painted at Cavalière, during the summer, it has elements of the approach and style of Byzantine icons.

■ Matisse, *Marguerite*, c.1907, Musée Picasso, Paris. Critics have linked this portrait with Japanese prints, pointing out the accentuated eyes.

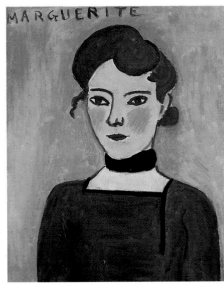

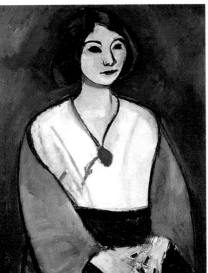

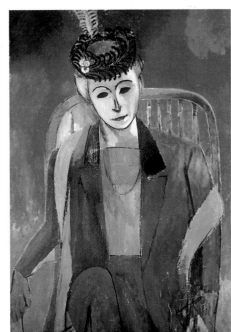

■ Matisse, *Woman in Green*, 1909, Hermitage, St Petersburg. The facial features are clearly drawn, while the hands remain indistinct.

■ Matisse, *Amélie Matisse*, 1913, Hermitage, St Petersburg. One of his more complex, elegant portraits, this was much praised by the writer Guillaume Apollinaire.

Matisse and Picasso

Picasso was born in Málaga in 1881, 12 years after Matisse, but his precocious ability was evident at an early stage, and the careers of the two artists ran parallel in some respects. They met for the first time in Paris in 1906, when they became the favourite artists of Gertrude and Leo Stein, the first people to understand them and appreciate their talents. It was Matisse who showed Picasso his first example of African sculpture (so important for the development of the *Demoiselles d'Avignon)*, taught him how to use bright colors, and provided him with useful technical advice on sculpting and engraving. It was Matisse, again, who introduced the Spanish painter to various collectors, in particular Sergei Shchukin, who went on to buy many of his early paintings. In the years that followed they kept in touch and their paintings were exhibited together. The "professor" Matisse saw Picasso as a talented but impetuous pupil, to whom he offered advice, and at the same time someone he admired for his willingness and inexhaustible vital energy. This paternal attitude softened the strong character differences and enabled him to overcome different aesthetic and stylistic concepts, fostering a lively friendship and rebutting the attempts of critics and journalists to invent an imagined rivalry between them.

■ If Matisse stood for grace and a decorative quality, Picasso was the embodiment of energy and strength. Matisse was calm and reflective, Picasso was unruly and impulsive. Matisse saw life as a garden of flowers to be contemplated with emotion; Picasso saw it as a wild mule to be tamed and ridden with equal energy. Despite this, or perhaps precisely because of this, each man found the other's ideas stimulating, resulting in mutual admiration and respect.

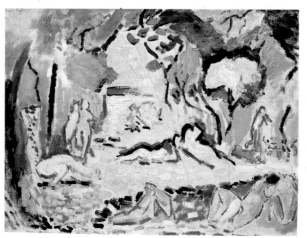

■ Matisse, *Sketch for Bonheur de Vivre,* 1906, Haas collection, San Francisco. This is one of the preparatory studies for the *Bonheur de Vivre* at the Barnes Foundation (Merion Station, Pennsylvania), perhaps the most successful synthesis of Matisse's thematic and stylistic references, from the classical mythology of Ingres, and from the Italian Renaissance, to the poetry of Mallarmé.

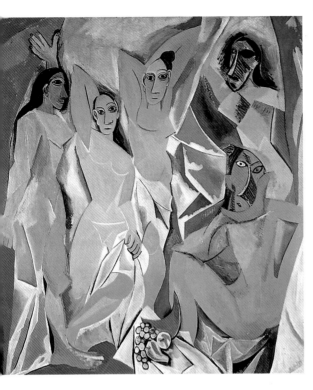

■ Picasso, *Les Demoiselles d'Avignon*, 1907, The Museum of Modern Art, New York. Preceded by an enormous quantity of drawings and preparatory studies, this is probably Picasso's finest masterpiece and marks a decisive turning point in western art of the 20th century.

■ Picasso, *The Harvesters*, 1907, Carmen Thyssen-Bornemisza collection. During the lengthy gestation of the *Demoiselles*, Picasso was drawn, albeit briefly, to the Fauve experience, producing this sketch, based on memories of Gòsol, the village in the Pyrenees where he stayed in 1906. The bright colors and warm light showed clearly that the artist had the works of Matisse in mind.

Two Masterpieces Compared

The relationship between Matisse and Picasso can be understood by comparing their most important works from these years, *Bonheur de Vivre* and *Demoiselles d'Avignon*, painted within a couple of months of each other, but very unalike. Paraphrasing Nietzsche, the sensuality of Matisse is Apollonian and therefore sunny and serene. In contrast, the spirit of Picasso is Dionysiac, dynamic and instinctive, closer to primitive cultures. The first seeks to reassure us, the second to startle. Similarly, where the style of the Frenchman is fluid, spacious, calm and makes use of curves, the Catalan painter's style is spring-loaded, taut, austere and dominated by straight lines.

1908–1910: The Matisse Academy and the introduction to Shchukin

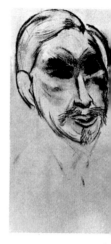

At the beginning of 1908, the Académie Matisse opened in the Couvent des Oiseaux, where the painter had already worked on *Bonheur de Vivre*. The academy was supported by Sarah Stein, wife of Michael Stein, his backer, by the German artist Hans Purrmann, future director of the academy, and by the American artist Patrick H Bruce. It was a success, attracting around 50 pupils, a fact that persuaded them to move to the ex-convent of Sacré-Cœur. However, teaching eventually became a burden to Matisse, and two years later, he abandoned it altogether. The same year he travelled to Germany with Hans Purrmann and held his first exhibitions abroad, in New York, London, Berlin, and Moscow. In 1909 Matisse moved to Issy-les-Moulineaux, a short distance southwest of Paris, to a house which he transformed into a living museum, with paintings, objets d'art, and carpets.

■ Matisse, *Portrait of Sergei Ivanovich Shchukin*, 1912, private collection. Shchukin was a Russian textiles entrepreneur, and an art collector. He started buying Matisse's work in 1906, and was soon joined by fellow Russian Ivan Morosov.

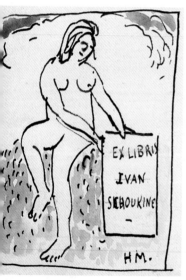

■ Matisse, *Ex libris for Shchukin*, Pushkin museum, Moscow. Daring and forward-looking, as he was in business, Shchukin began to collect works of art in the 1880s.

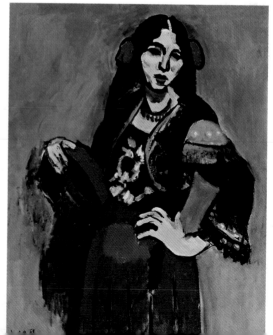

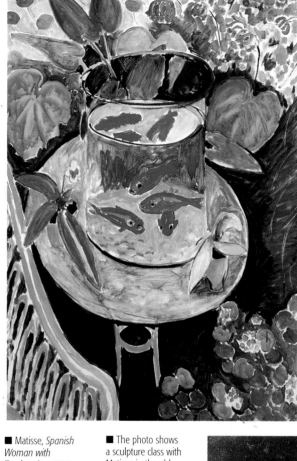

■ Matisse, *Goldfish*, 1911, Pushkin museum, Moscow. Another of the numerous purchases made by Shchukin. The motif of the goldfish bowl can be found in many other paintings by Matisse, usually placed in the foreground. Here the reflections of the fish in the water are surrounded and accentuated by the dazzling colors of the flowers and the leaves from his garden. The entire composition plays around elliptical and circular movements, repeated and emphasized by the circular table.

■ Matisse, *Spanish Woman with Tambourine*, 1909, Pushkin museum, Moscow. One of Shchukin's purchases, the painting is very solidly drawn. Unlike other paintings of the time, the background is simple, almost monochrome, perhaps to emphasize the figure. There is almost an invitation to dance in her direct gaze.

■ The photo shows a sculpture class with Matisse in the old convent of Sacré-Cœur, in the Boulevard des Invalides. From the left, the Norwegian Heiberg, an unknown woman, Sarah Stein, Purrmann, Matisse, and Bruce. Matisse took a fairly traditional line with teaching: placing great emphasis on drawing and study of past masters.

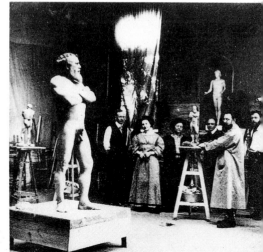

"La Danse" and "La Musique"

On March 31, 1909, Shchukin commissioned Matisse to produce two large decorative panels, depicting allegories of music and dance, which were completed the following year (the panels are now in the Hermitage, St Petersburg).

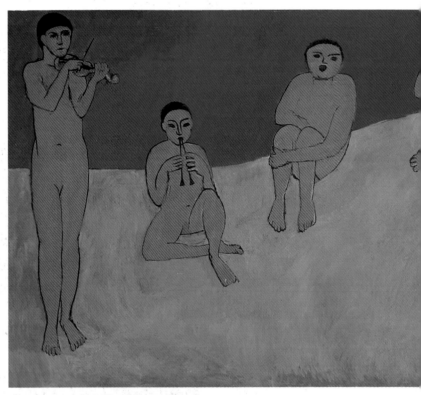

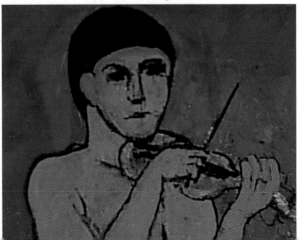

■ Matisse re-elaborated a sketch made in Collioure in 1907, and the figure of the violinist is strikingly similar. Matisse was musical himself, keeping a small harmonium in his studio (see pp. 22–23) and he was a fair violinist, good enough to play occasionally in the company of experienced musicians.

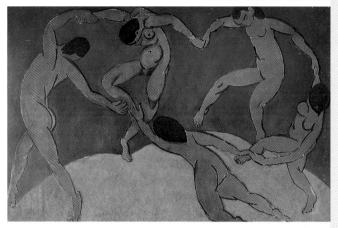

■ The initial idea for *La Danse* can be found in the six dancers who appear in the background of the Barnes Foundation's *Bonheur de Vivre*. Matisse cuts out one figure and adapts the composition to the rectangular form of the painting. Its great novelty lies in the color shading, which is strong and much more decisive, but the main focus is the emphasis on the tension of the bodies, depicted unleashing an incredible vital energy.

■ Matisse, *Nasturtiums in "La Danse"*, 1912, Pushkin museum, Moscow. Matisse had already put *La Danse* into the background of a still life painted in 1909 (Pushkin museum, Moscow). Another version of this painting, dated 1912, is now in the Metropolitan Museum of Art in New York. It is a picture within a picture, linking the dancers' vitality to the life in the flowers.

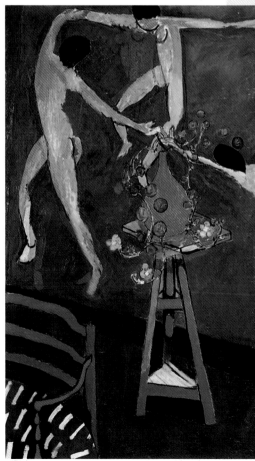

59

1911: Moscow

In the spring of 1908 Matisse sent several of his paintings for the Toison d'Or exhibition, in which 51 French artists were taking part. The following year he presented three paintings, again at the Toison d'Or; the entire art section of the magazine *Zolotoye Runo* was devoted to his painting, which was enthusiastically reviewed. In autumn 1911, at the invitation of the art collector Shchukin, he went to Russia: after a brief stay in St Petersburg, he was a guest for two weeks at Shchukin's house in Moscow, to see the city, visit the museums, and to meet other artists. Here he really felt he was in direct contact with the Orient: "The revelation came to me from the East. It was only later that this art touched me and I understood Byzantine painting in front of the icons of Moscow", he wrote in 1947. This new experience enriched his palette with new colors and evoked an enormous number of new impressions and ideas, which he was not slow to translate onto canvas.

■ Matisse, *La Chambre Rouge* or *Harmony in Red,* 1907, Hermitage, St Petersburg. The large canvas was initially painted in green and presented as *Harmony in Green,* then Matisse painted it blue, and at this point sold it to Shchukin and exhibited it as *Harmony in Blue.* Prior to delivery, however, he changed his mind again, repainting it with a bright, dazzling red. It is one of the first paintings in which, apart from the intense coloring, decorative elements appear in the foreground, an aspect which would become a principal characteristic of his subsequent work.

■ Matisse is pictured in the autumn of 1911 in his studio at Issy-les-Moulineaux, painting *Still Life with "La Danse"* (now in Moscow, at the Pushkin museum); in the background you can glimpse one of the numerous full-size studies for *La Danse.*

■ Moscow, the cathedral of St Basil in Red Square. Matisse was warmly welcomed by admiring young Russian artists.

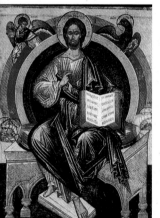

■ School of Novgorod, *Christ the Saviour among the Powers,* Russian State Museum, St Petersburg. Matisse was particularly struck by icons, which he admired at the house of Ostruchov, curator of the Tretyakov gallery.

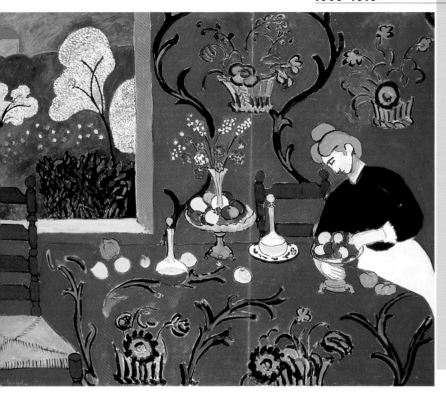

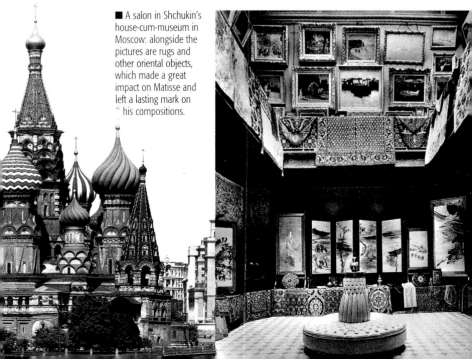

■ A salon in Shchukin's house-cum-museum in Moscow: alongside the pictures are rugs and other oriental objects, which made a great impact on Matisse and left a lasting mark on his compositions.

The Conversation

Painted between the winter of 1908 and the summer of 1912, *The Conversation*, now in the Hermitage in St Petersburg, depicts an apparently simple scene, in which the artist, in pyjamas, is saying good morning to his wife.

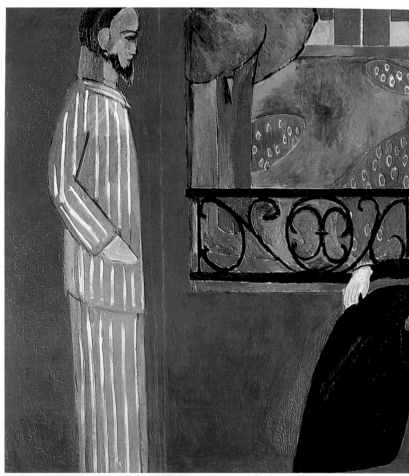

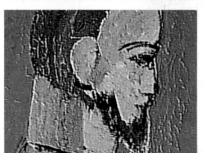

■ The solemn, monumental bearing of the two figures, and the familiar interplay of interior and exterior space created by the window looking out onto the garden, plus the atmosphere of calm created by the intense blue filling the background, have given rise to any number of interpretations. The painting appears highly unsettling and mysterious.

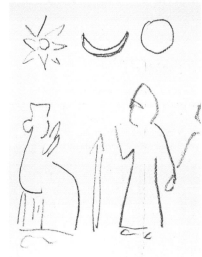

■ Matisse, *Drawing from a sketchbook*, private collection. This drawing, which shows the king in front of the seated goddess, was with another similar drawing, in a sketchbook of studies that Matisse used for the whole of 1913. It demonstrates his intention to show the link with the Kassite stele.

■ Simone Martini, *Annunciation*, detail, 1333, Uffizi, Florence. The reference to the masterpiece by Simone Martini, so explicit as to appear a "homage" to ancient Italian art, which Matisse had seen on his travels there in 1907, removes the everyday quality and elevates it into a work of great spirituality, a kind of lay *Annunciation*.

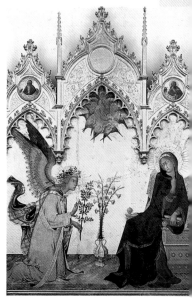

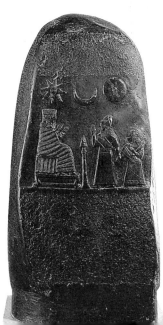

■ Kassite stele, *Kudurru di Melis, HU II,* Musée du Louvre, Paris. As Roger Fry had already remarked, when he persuaded Matisse to loan the painting (owned by Shchukin) for an exhibition in London, "he appears placid, monumental and assured, like an ancient Assyrian sculpture".

1911–1913: Morocco

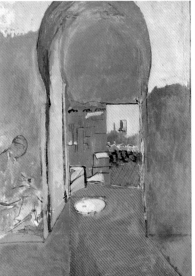

In May 1906 Matisse made his first visit to north Africa, to Biskra in Algeria, "to see the desert" and to re-live the experiences of Delacroix. In the autumn of 1910 he went to Munich with Marquet and Purrmann, for an exhibition of Islamic art. In the winter of 1911–1912 he went to Tangiers in Morocco and returned there the following year, encouraged by requests from his Russian collectors, Shchukin and Morosov. Here he met Marquet, Camoin, and the Canadian painter James W Morrice, but more crucially, he was introduced to the light and hot colors of Africa, which warmed and completely refreshed his color range. He concentrated on varying the relationships of colors in a picture, experimenting with various solutions, favouring first one shade, then another. The increased presence of decorative values was noticeable as well as a lessening of depth, with some paintings almost in two dimensions. The Moroccan experience led to a burst of energy and creativity and when Matisse returned to Issy he resumed a number of familiar themes with a new eye, as in his portrait of Amélie of the summer of 1913 (see p. 53).

■ *Riders reaching the Castle Gate*, Iran c.1500. Musée des Arts Décoratifs, Paris. The closely woven decoration, the drawings, and the fairy tale atmosphere greatly affected Matisse.

■ Matisse, *Entrance to the Kasbah*, 1912, Hermitage, St Petersburg. Originally there were two people on the left and one on the right, standing. Matisse changed his mind and eliminated two, blurring the third, on the left, so that the figure is almost flattened against the wall. It has lost its physical shape and it too has acquired the function of a decorative element.

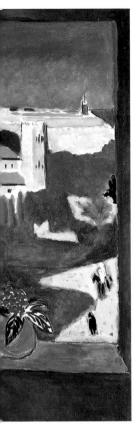

■ Matisse, *Window at Tangier*, 1912–13, Pushkin museum, Moscow. With *Entrance to the Kasbah* and *Zorah on the Terrace*, this completed the "Moroccan triptych", bought by Morosov. Blue is dominant, making the two vases of flowers stand out in the foreground. In the distance white walls are visible.

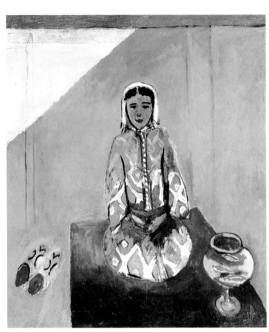

■ Matisse, *Zorah on the Terrace*, 1912, Pushkin museum, Moscow. Once again the artist has deliberately left the hands of Zorah, his preferred model on these two Moroccan trips, incomplete and smudged.

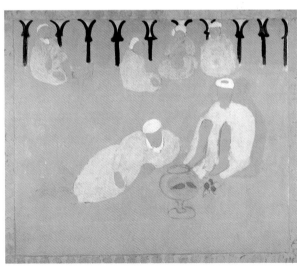

■ Matisse, *The Arab Café*, 1912, Hermitage, St Petersburg. The artist has simplified the details to the point of utter dissolution into abstract; the figures seeming to float in the void, like the two goldfish in the vase.

Standing Riffian

Matisse, *Standing Riffian*, 1912, Hermitage, St Petersburg. Matisse met a Riffian, "a kind of mountain dweller, as magnificent and wild as a jackal" and drew him in two poses, standing and seated (Merion Station, Barnes Foundation).

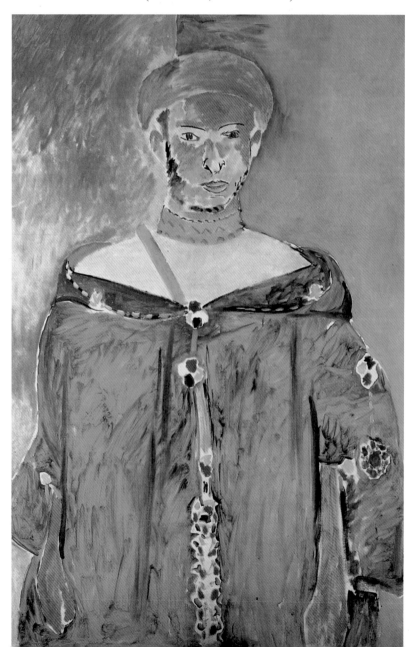

■ When he painted portraits, Matisse observed the local people, but in his mind he saw the saints in Russian icons. He did not depict people as they were, instead depicting them in sober, timeless poses, emphasized by pure and brilliant colors and by dense, heavy brushstrokes.

■ Matisse, *Zorah Standing*, 1912, Hermitage, St Petersburg. Having painted her on his first trip, the artist discovered his model Zorah in a brothel and, since the Koranic law preventing women from showing their faces did not extend to prostitutes, he persuaded her to pose for other paintings.

■ Matisse, *Amido,* 1912, Hermitage, St Petersburg. In Morocco Matisse painted a great deal, fascinated by its natural and artistic appeal: still lifes, views, landscapes, portraits, and general scenes. In 1916 he produced one of his masterpieces, *The Moroccans.*

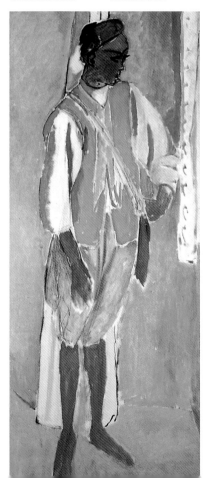

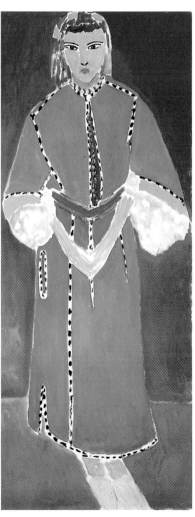

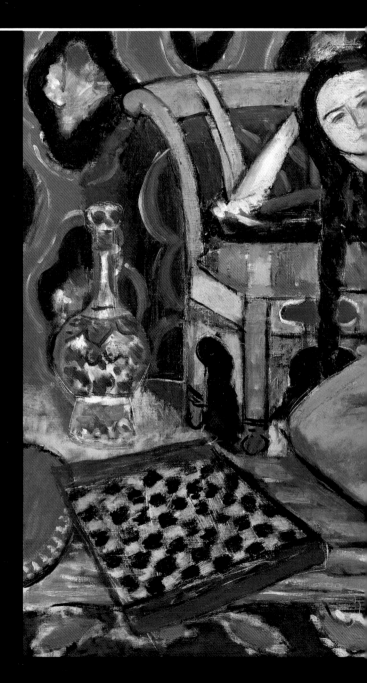

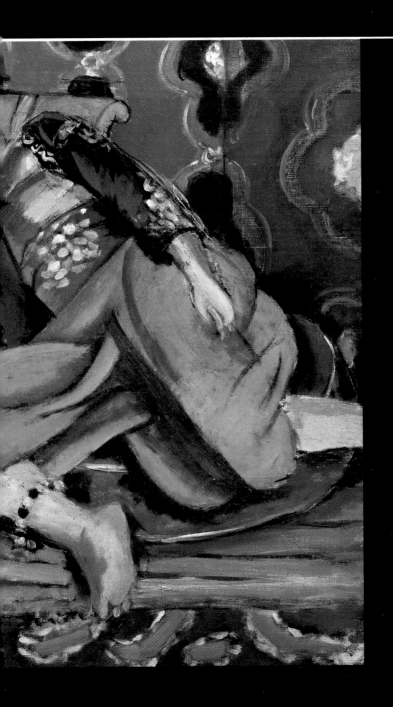

LIFE AND WORKS

1914–1915: war and meeting Juan Gris at Collioure

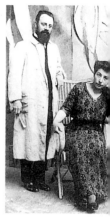

On June 28, 1914 Franz Ferdinand, heir to the Austrian throne, and his wife were assassinated at Sarajevo by the Bosnian student Gavrila Princip. World War I broke out, France allied with England, Russia and, the following year, Italy, against Germany, Austria and Turkey. Matisse and Marquet tried to enlist, aiming to follow Derain, Camoin, and Puy to the front, but their application was refused. As German troops neared Paris, Matisse moved with his family first to Toulouse, and then to their villa at Collioure. Here he found Marquet and met Juan Gris, the Madrid artist who, with Picasso and Braque, had contributed to the birth of Cubism. He also met the Cubists Albert Gleizes and Jean Metzinger, discovered the philosophy of Henri Bergson, and visited exhibitions put on by the Expressionist movement *Die Brücke* and the *Blaue Reiter* group, led by Wassily Kandinsky. He also frequently saw Gino Severini, one of the five key figures in the Futurist movement. Their lengthy discussions on art were crucial for the transformation which had already begun on the two trips to Morocco: the change was decisive and profound, and induced Matisse to modify his painting radically. In January 1915 he put on a show at the Montross gallery in New York, at which he presented his new work.

■ Talking to Gris inspired Matisse, seen here with his wife in the studio, to experiment with new colors and different spatial solutions.

■ Matisse, *The Yellow Curtain*, 1915, Alphonse Kann collection, New York. This is one of his more abstract paintings: through the window an oval swimming pool can be seen, surrounded by leaves against the sky.

■ Matisse, *French Window at Collioure*, 1914, Musée National d'Art Moderne, Paris. The straight line and the wide background bands of pure color dominate; these are the enigmatic limits of minimalism.

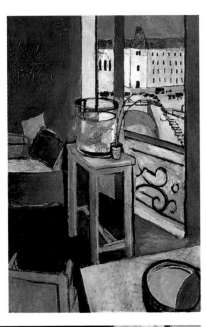

■ *Interior, Goldfish Bowl*, 1914, Musée National d'Art Moderne, Paris. Many familiar elements are here (the window, the goldfish bowl). The theme is revived and given more intimacy.

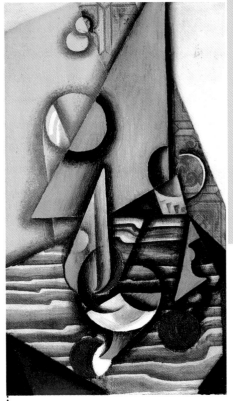

■ Gris, *Glasses on a Table*, sold at Sotheby's, May 10, 1988. The Cubism of Gris was born of a rigorous process of simplification of spaces, arranged on the canvas like the notes on a musical score.

Who christened Cubism?

The term is usually said to have originated in an article by the critic Louis Vauxcelles, who wrote for the magazine *Gil Blas* in 1908. It appears to have been suggested to him by Matisse, who later denied the episode. When the Salon jury of 1908 was inspecting the work of Braque, Matisse, a member of the jury, exclaimed: "Toujours les cubes!" (all these cubes!).

A parallel journey, Wassily Kandinsky

Wassily Kandinsky was born in Moscow in 1866. He embarked on a legal career but at the age of 30 resigned his university chair and went to Munich, to study painting. At first he painted landscapes, inspired by the Russian tradition, then he discovered Pointillism. Between 1908 and 1910 he lived in Murnau, where he met Alexei von Jawlensky, who told him about Matisse and converted him to Fauve painting. Gradually, however, the objects he painted started to dissolve, and color began to take over from form: with the series *Improvisations* his work became almost abstract. In 1911 he founded the group Der Blaue Reiter with Marc and Macke and took part in shows in Berlin and Munich, concentrating on geometrical abstracts. At the outbreak of World War I he returned to his native country and actively followed events in the Russian revolution. In 1921 Gropius invited him to teach at the Bauhaus, until the advent of Nazism forced him into exile in France, where he died in 1944.

■ Kandinsky, *Untitled*, 1941, sold at Finarte, November 16, 1993. In Paris his compositions were enriched by "biological" forms, inspired by Arp and Miró.

■ Kandinsky, *Rapallo*, 1906, private collection. During this period Kandinsky was spreading color on the canvas with a spatula, in dabs, creating dense, heavy reflections.

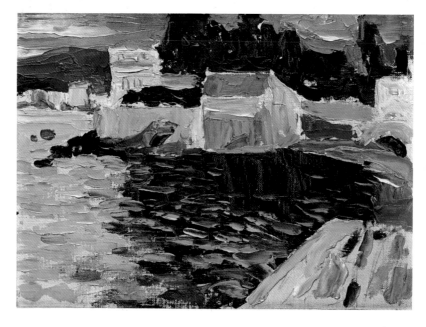

■ Kandinsky, *Study for Painting with Two Red Cars,* 1916, Civico Museo d'Arte Contemporanea, Milan. The artist discussed his theories of the abstract in two essays: *Point and Line to Plane* and *Concerning the Spiritual in Art.*

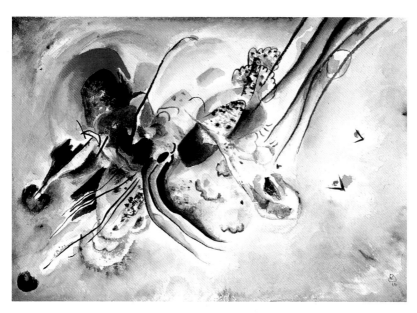

■ Kandinsky, *Murnau,* 1908–1909, private collection. During his time in Murnau, in Bavaria, Kandinsky went back to his brushes, using warm colors, arranged in a fluid, expansive way. His landscapes contain echoes of Gauguin and Van Gogh, but on the whole consciously assimilated the Fauvist work of Matisse.

Marguerite, White and Pink Head

Marguerite, White and Pink Head (1915, private collection) is one of Matisse's most Cubist works and the most faithful to its theories. The facial features have been transformed into a pentagon, with sides stretching out into infinity.

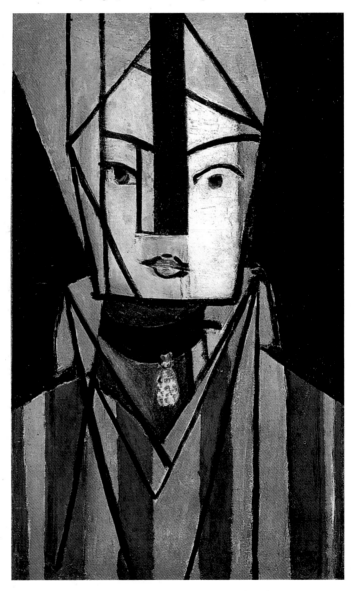

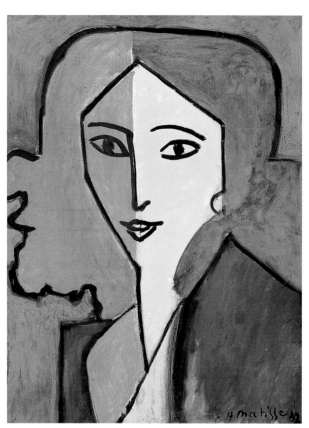

■ Matisse, *Portrait of Lydia Delectorskaya*, 1947, Hermitage, St Petersburg. The distinct partitioning of the face into two sections is reminiscent of the portrait of his wife from 1905 (see p. 52). Unlike *White and Pink Head* (see left), the application of Cubist principles is less rigorous, but more emotive and rich with poetry.

■ Picasso, *The Sailor*, sold at Sotheby's, June 28, 1988. The compositional approach used by Matisse in the portrait of his daughter Marguerite is very similar to that used by Picasso in this painting, for instance the choice of a striped top and seeing the face as a pentagon. However, while Picasso seems to be at ease with the style, almost casual, Matisse does not give the impression of having mastered the technique, with more static and awkward results.

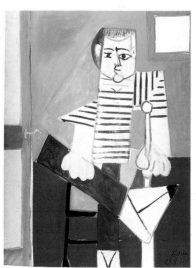

■ Luca Cambiaso (1527–1585), *Perspective Study for a Figure*, private collection. Cubism invented nothing new. For centuries artists had been trained to reduce volumes to cubes, in order to study perspective. The Cubist revolution consisted in using this method not as a means, but as the final aim of the exercise.

1916–1917: Paris, Issy-les-Moulineaux

At the end of 1915 Matisse moved from the Paris studio on the Quai Saint-Michel to the one at Issy-les-Moulineaux. The next two years were marked by the war, which affected him directly: his brother, a reserve officer, was taken prisoner and taken to Heidelberg; later his two sons were called up, Pierre joining the Tank Corps, Jean the auxiliary services of the Air Force. Writing to Derain he confessed his "anguish with the constant waiting for developments in the war". Yet they were years of intense activity, during which he produced several of his masterpieces, from *The Moroccans* to *Piano Lesson*. With tremendous patience he studied Cubism, attempting and re-attempting various stylistic solutions. "L'esprit de géométrie" became his constant reference: "The plumb line, determining the vertical direction, forms, with its opposite, the horizontal, the draughtsman's compass". Even his palette changed: instead of bright, vivid colors, greys began to predominate, and dark shades, from green to brown and even black.

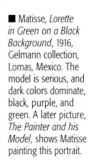

■ Matisse, *L'Atelier, Quai Saint-Michel*, 1916, Phillips collection, Washington. Through the window the Palais de Justice is visible; inside, a sketch of the model (Lorette), who is stretched out on the divan, is propped on one of the two chairs.

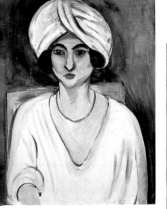

■ Matisse, *Lorette with White Turban*, c.1916, Baltimore, Cone collection. Lorette was an Italian model, who posed for Matisse in a series of portraits produced between 1916 and 1917.

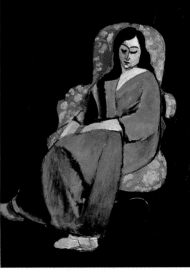

■ Matisse, *Lorette in Green on a Black Background*, 1916, Gelmann collection, Lomas, Mexico. The model is serious, and dark colors dominate, black, purple, and green. A later picture, *The Painter and his Model*, shows Matisse painting this portrait.

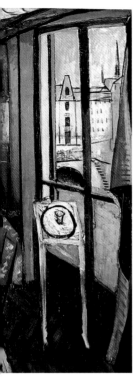

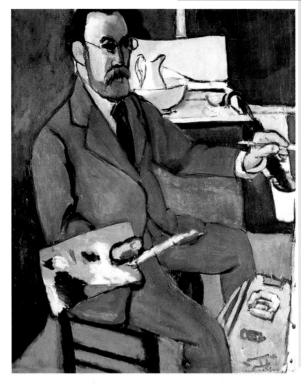

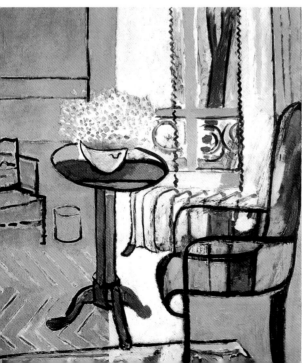

■ Matisse, *Self Portrait*, 1918, Musée Matisse, Cateau-Cambrésis. These two years were an important period of reflection for Matisse, during which themes from earlier years came together and he gained full expressive maturity.

■ Matisse, *The Window; Interior*, 1916, Detroit Institute of Art, Detroit. The artist frequently returned to one of his favourite themes, the window. Each time he approached it in a different way. Here the space, which has almost no depth, is defined by the black lines and by the white light.

MASTERPIECES

The Piano Lesson

The Piano Lesson, 1916, Museum of Modern Art, New York. This familiar scene representing an interior offers subtle symbolic allusions, which make the painting both disturbing and endlessly fascinating.

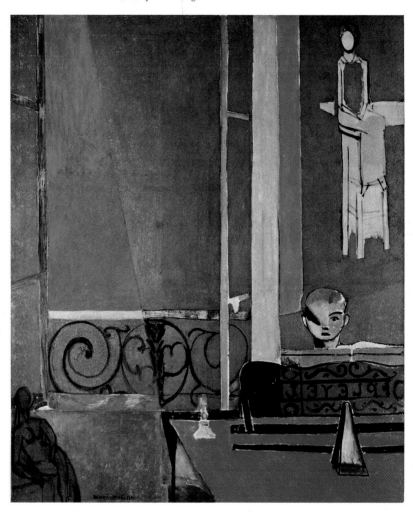

■ In 1916 Matisse's son Pierre, intent on playing the Pleyel piano, was 16 years old, although he seems much younger here. The shadow falling over his eye echoes the triangular shape of the metronome on the piano.

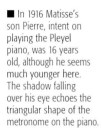

■ This detail echoes, in a more simplified form, a painting of 1914, *Woman on a High Stool*, one of the first of the Cubist-inspired compositions. The woman is Germaine Raynal, wife of the Cubist critic Maurice Raynal, who had been painted the previous year by Juan Gris.

■ In the bottom left-hand corner, at the opposite extreme from the seated woman, is the sculpture *Decorative Figure*, executed in 1908. The artist wanted to compare and contrast the sinuous, sensual lines of the statuette, for which he used a warm color, with the rigid geometry and cool colors of the picture as a whole.

■ The two-dimensional representation of the candle holder, in hot colors, appears in stark contrast to the three-dimensional form and the grey tones of the metronome. Critics have read symbolic significance into the scene, identifying the opposing elements of the creative process, with emotional, irrational intuition on one side, and on the other side deliberate rationality.

1917–1919: the early years in Nice

In December 1917 Matisse visited Nice for the first time, staying at the Hôtel Beau-Rivage, which faced the sea on the Promenade des Anglais. On December 31 he paid a visit to Auguste Renoir, who lived in the nearby town of Cagnes-sur-mer, subsequently taking several paintings that the elderly master admired (he was 76 and died on December 3, 1919). The mild climate and the relaxing, tranquil environment gave new impetus to Matisse's creativity, despite the continuing war, so much so that from that point onwards he only returned to Paris for brief periods; in summer or for work-related matters. In the meantime he bought a car, so that he could transport all his equipment when he wanted to paint landscapes. The following year saw him again in Nice, not at the Beau-Rivage, requisitioned by the American military, but at the Hôtel Méditerranée, where he remained for three seasons, until 1921. At Antibes he met Bonnard and Picasso, with whom he exhibited at Paul Guillaume's gallery; he met the poet André Rouveyre at Vence and spent a few days at Marseille with Marquet and Georges Besson.

■ In September 1921 Henri and Amélie Matisse rented an apartment at Place Charles-Félix, in the old part of Nice. From the window the Mediterranean was visible over the long, low roofs of the Ponchettes building, which appears in some of the artist's paintings.

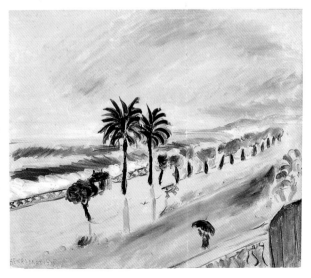

■ Painted between 1919 and 1920, *Storm over Nice* (Musée Matisse, Nice) depicts a storm over the Baie des Anges in a style that represents a return to the ways of the Impressionists (perhaps in homage to Renoir), but also a relaunch of the 19th-century landscape painting tradition of Corot and Courbet.

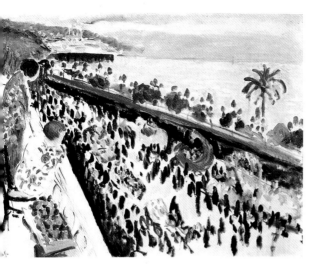

■ Matisse, *Festival of Flowers*, 1921, Hôtel Méditerranée, Nice. The overhead perspective is reminiscent of the works produced in Paris with Marquet, while the elongated diagonals are derived from Japanese prints.

■ Here, the artist returns to the theme of the open window (*Woman with a Parasol*, 1918–19, Hôtel Méditerranée, Nice), playing with the relationship of inside-outside and light-shade.

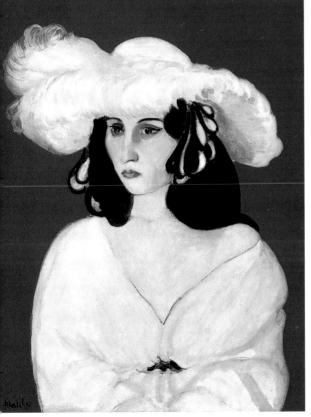

■ Matisse, *The White Plumes*, 1919, Minneapolis Institute of Arts. Between 1918 and 1919 Matisse painted the model Antoinette Arnoux, here portrayed in one of his more expressive, intense paintings. The simplicity of the dress and the monochrome back-ground brings out the wide-brimmed hat, made especially for this picture by the artist.

The Côte d'Azur, land of art and artists

■ In 1860, with the Treaty of Turin, signed by Napoleon III and Victor Emanuel II, Nice (seen here in a photo dating from 1927) was annexed to France. The town went on to develop considerably, becoming a prestigious holiday resort, with large luxury hotels, bathing beaches, and casinos.

From the Belle Époque years onwards the Côte d'Azur was the favoured resort of famous personalities, among them many artists, who found it a stimulating environment for their work. "The days follow each other here with a beauty which I would describe as insolent; I have never experienced such perfectly settled winter weather", wrote Nietzsche to his sister in 1883, while searching for inspiration to finish *Also Sprach Zarathustra*, and Chekhov could have said the same when he was writing *Three Sisters*. Besides rich Englishmen and Russians, the lovely beaches and enchanting villages of the hinterland were the haunt of writers, musicians, architects, painters and, more recently, film directors and designers, seduced by the mild climate, the colors, the lush vegetation, all of which created a unique, unmistakeable atmosphere. The towns, already proud of monuments dating back to the ancient Greeks, were embellished with villas designed by top architects and designers. The list of painters alone would fill an entire page, and the masterpieces produced here have been collected in 30 or more foundations and museums, scattered across 15 or so towns. Some concentrate on one artist, such as Picasso in Antibes, Matisse and Dufy in Nice, Léger at Biot, Jean Cocteau in Menton, Magnelli at Vallauris, constituting an extraordinary synthesis of 20th century art.

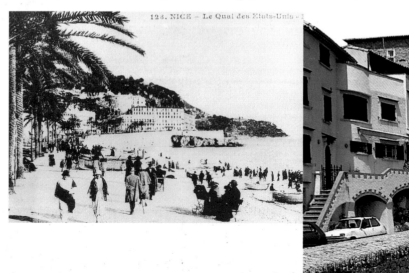

123. NICE – Le Quai des États-Unis – 1

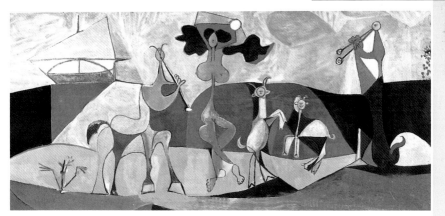

■ Pablo Picasso, *The Joy of Life*, 1946, Musée Picasso, Antibes. In 1946, Picasso settled at Mougins, fascinated by the position of Notre-Dame-de-Vie, where he lived until his death in 1973. At the invitation of Dor de la Souchère, he often worked at the Château Grimaldi at Antibes, which now houses a museum dedicated to him.

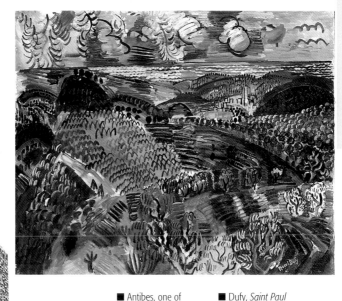

■ Antibes, one of the most fascinating and poetic villages on the Côte d'Azur. In the background is the Château Grimaldi, now the home of the Musée Picasso.

■ Dufy, *Saint Paul de Vence,* sold at Finarte, October 30, 1996. This is one of the most atmospheric villages in Provençe, full of fascination and charm, with old houses squeezed into narrow cobbled streets.

Sculpture

Two Negresses, 1908, Musée Matisse, Nice. This piece was presented at the Salon in 1908, in a retrospective devoted to his sculpture. It is a fusion of plastic art and classical statuary, which he had studied at the École and in Italy.

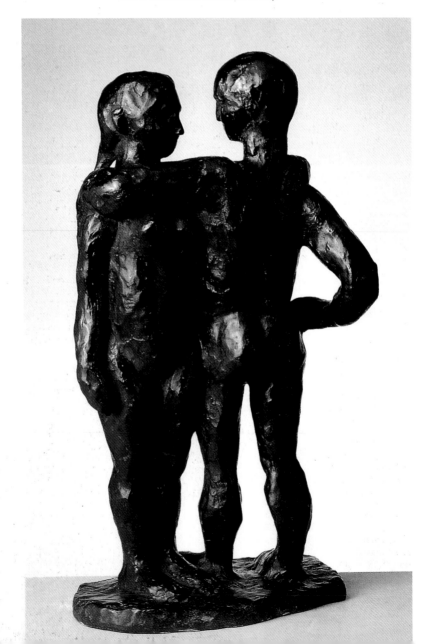

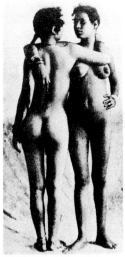

■ Matisse used a photo as the basis for Two Negresses (*Deux Négresses)*. The artist toned down the sensual, Sapphic allusions in the photo and accentuated the monumental quality, making the figures stocky and solid, in contrast to the decorative quality of his paintings.

■ Matisse, *Reclining Nude*, 1925, Berggruen collection, Geneva. The pose of this bronze derives from a drawing of 1923 and from a painting from the same year, *Odalisque with Raised Arms* (The Art Institute of Chicago, Chicago). In 1925 he produced three lithographs, in particular *Nu au Fauteuil*. Here, however, the support of the armchair is absent, producing an effect of great tension and equilibrium.

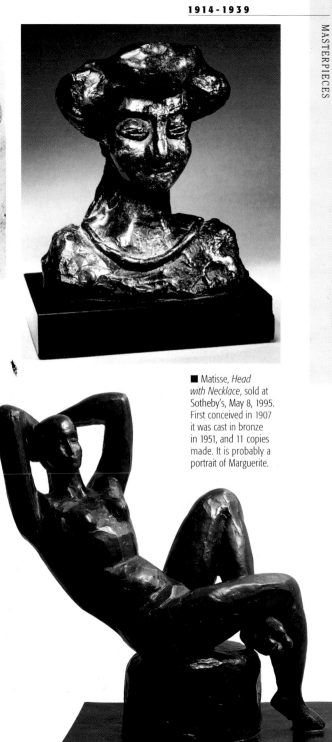

■ Matisse, *Head with Necklace*, sold at Sotheby's, May 8, 1995. First conceived in 1907 it was cast in bronze in 1951, and 11 copies made. It is probably a portrait of Marguerite.

A century of great sculptors

■ Hans Arp, *Marble*, sold at Sotheby's, November 1995. Founder and animator of Dada, the German artist constantly sought conceptual purity, gaining inspiration from nature, in particularly from the simplest organisms.

■ Marino Marini, *Rider*, 1951, sold at Sotheby's, May 8, 1995. Marini was one of the great upholders of the Italian sculptural tradition, with simple forms, rich with expressive force and dramatic intensity.

In the field of sculpture the 20th century has been rich with change, often as a result of great technical and stylistic innovations. Starting with Rodin, the tradition of 19th century monumentalism was radically revised and found expression in a multitude of diverse forms according to different factors: the individual artist's personality, the artist's relationship with the surrounding cultural environment, and the changing requests and needs of the emerging art market. Two different styles can be distinguished: monumental sculpture on a major scale, intended for town squares, parks, or other public buildings, and objects created on a smaller scale, "for the home", sometimes in marble or stone, but more frequently in bronze, majolica, or ceramic. There were also artists who pursued and reinvented figurative sculpture, and experimented with innovations, whether abstract, geometrical, or informal. The language of sculpture increasingly broke away from painting, with artists pursuing their own, individual paths, often with astonishing results.

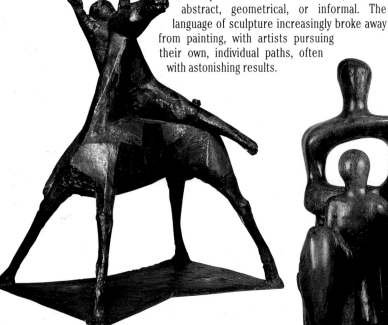

■ Henry Moore, *Family Group*, private collection. His powerful, solid style has often been compared with Michelangelo's.

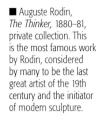

■ Auguste Rodin, *The Thinker,* 1880–81, private collection. This is the most famous work by Rodin, considered by many to be the last great artist of the 19th century and the initiator of modern sculpture.

■ Constantin Brancusi, *The Fish*, private collection. The Romanian sculptor, a pupil of Rodin, was drawn to primitive art and produced abstract works of extreme rigour and simplicity, stylized in form.

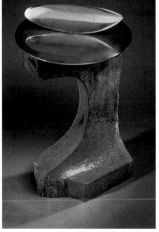

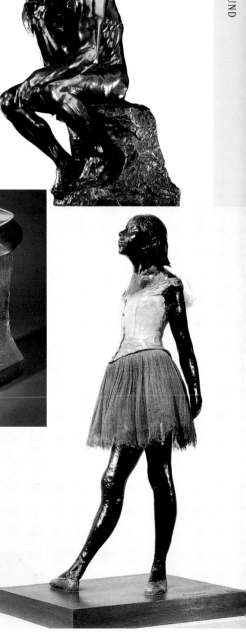

■ Edgar Degas, *Little 14-year-old Dancer*, 1880, private collection. Among the 150 or so sculptures found in Degas' studio after his death in 1917, this was the only one that had been shown at the sixth Impressionist exhibition in 1881. It was particularly striking because of the use of a tutu made with real tulle over the bronze.

Nice: the odalisques

Between 1919 and 1929, Matisse painted around 50 canvases depicting harem odalisques, in different poses and with varying backgrounds. These paintings, preceded by a large number of preparatory drawings, were accompanied by pictures depicting other similar female figures (Oriental, Persian, Hindu or Moorish women). They were followed by a prolific output of graphic art (lithographs, etchings and drypoints) and sometimes by sculptures which echoed the poses drawn, as in *Reclining Nude* of 1925 (see p. 85). A source of inspiration was the series of odalisque portraits by Delacroix, made between 1826 and 1834, and the equally famous ones portrayed by Ingres and later, by Renoir. "The *Odalisques*", wrote Matisse, "were the bounty of a happy nostalgia, a lovely, vivid dream, and the almost ecstatic, enchanted days and nights of the Moroccan climate". The artist succeeds in conveying a sense of living, serene sensuality, such as can be found in *Luxe, Calme et Volupté* (see p. 28) or in *Bonheur de Vivre*, although here the figures are not placed in a landscape, but in an interior, almost always furnished with European objects.

■ Matisse in his studio, c.1927–28. Scrupulously meticulous, Matisse loved to create a kind of stage set in his Nice apartment, on which he could arrange the elements of the picture he wanted to paint, and then study them, executing quantities of sketches in pencil or charcoal.

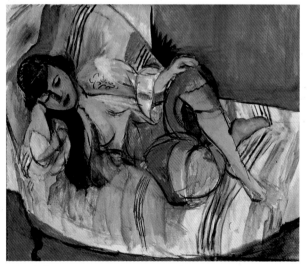

■ Matisse, *Odalisque*, 1923, Stedelijk Museum, Amsterdam. In 1922 a large colonial exhibition opened in Marseille, breathing new life into the Orientalist tradition. A few months later, Léonce Bénédite, president of the Society of French Orientalist artists and director of the Luxembourg, bought *Odalisque in Red Harem Pants* for the museum. It was the first of Matisse's paintings to be hung in a Paris museum, enhancing his prestige and increasing interest from collectors.

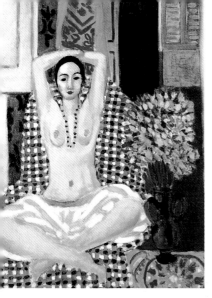

■ Matisse, *The Hindu Pose*, 1923, sold at Sotheby's, May 8, 1995. The model, Henriette Darricarrère, is shown with crossed legs and arms clasped behind her head. Her necklace, reduced to bright spots of black and yellow, echoes the white, black, and blue of the armchair. Next to her is a large green vase with purple flowers, which stand out against the brown background of the floor.

■ Matisse, *Odalisque*, 1925, Civico Museo d'Arte Contemporanea, Milan. Almost all of the elements of *Hindu Pose* are present here, but the model is standing and has moved across to the shuttered window, through which daylight filters. Certain details, like the slippers, at the bottom, make the scene more composed and intimate. There are fewer color contrasts and the presence of shadows makes the room feel more realistic.

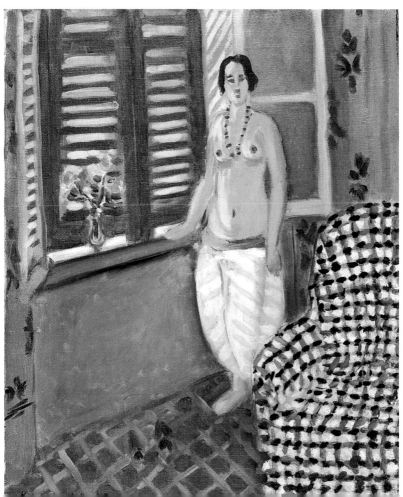

Orientalism and orientalisms

Orientalist art was part of a wider cultural phenomenon that developed in France in parallel with the founding of the colonial empire in Africa. "The whole of Europe looks to the East", wrote Victor Hugo of his *Les Orientales*, published in 1829. Ten years earlier Byron had celebrated the cult of odalisques in his poem *Don Juan*. Many artists were inspired to travel abroad, some to document events, others in search of new inspiration. The impact of a new landscape, so different from France, with exotic cities, people, customs, and clothes, created a new multi-faceted fashion. In the main, artists were in search of fresh themes for romantic interpretation; themes that could be set against the traditional depictions of the Neoclassicists. "The heroes David and his companions", wrote Delacroix, "with their pale limbs, would cut a very poor figure alongside these sons of the sun". At the Salon of 1827 the painter compared Ingres' *Apotheosis of Homer*, with *La Mort de Sardanapale*, inspired by one of Byron's poems; in 1855, at the Great Exhibition, while Ingres exhibited a rather stiff *Joan of Arc*, Delacroix presented a stirring, bloody *Lion Hunt in Morocco*, in the style of Rubens.

■ Delacroix, *Les Femmes d'Alger*, 1834, Musée du Louvre, Paris. In 1832 Delacroix, at the invitation of Count Charles de Mornay, spent some time in Algeria and Morocco, taking away with him strong impressions and the inspiration for many of his canvases, among them this one below. On seeing the painting, Renoir wrote "you can practically smell the aroma of the incense burning slowly in the Oriental hookah".

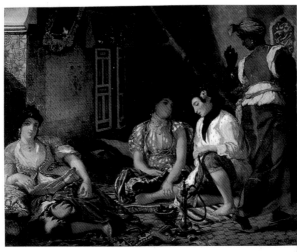

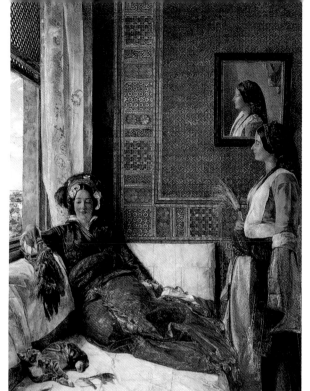

■ John Frederick Lewis, *Life in the Harem*, 1857, Laing Art Gallery, Newcastle-upon-Tyne. The theme of the odalisques and the harem developed in Europe in the 18th century, as some of the paintings of Boucher testify. The theme became widespread in the 19th century and developed into a genuine artistic genre, allowing artists to set a languid, passionate sensuality, of a romantic stamp, against the polished, but cold eroticism of the Venus of mythology, so dear to the Neoclassicists.

■ Ingres, *Turkish Bath*, 1862, Musée du Louvre, Paris. Although he was considered a "classic" painter, Ingres tried his hand at Orientalist subjects with success.

■ Pasini, *The Garden in the Harem*, 1877, private collection. Pasini's work derives from travel to the Orient with the ambassador Bourrée.

Decorative Figure

This *Decorative Figure* (1925–26, Musée National d'Art Moderne, Paris) is one of Matisse's most sublime studies of the human figure and of the relationships between the plastic dimension and the decorative.

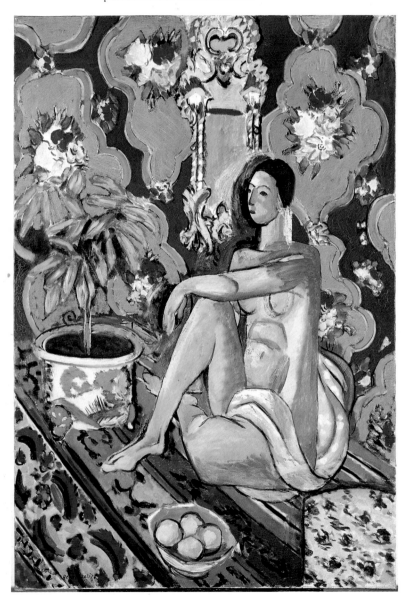

■ Matisse simplified the human figure, drawn to the linearity of the schematic elements. The woman's body is arranged like a pyramid and the face has become an oval, reflected in a mirror with an incredibly elaborate frame, surrounded by equally rich floral decoration.

■ In his etchings his drawing was precise and complete, but in paintings the color took the upper hand, distorting and obscuring detail. Here too, as has already been seen in *Zorah on the Terrace* (see pp. 64–65), the hands have almost dissolved, the fingers reduced to pure smears of light.

■ In his studio Matisse had set up a large wooden trestle on which he used to hang material and multicolored rugs, which then acted as backgrounds for his paintings. There is no depth to them, only a free play of intense light, without shadowing, and bright colors, a lesson seemingly absorbed from the work of abstract painters.

Exoticism and primitivism

O ne of the most characteristic aspects of 20th century art is the awareness of non-European cultures. Interest in foreign cultures has long existed, ever since people returned from their travels with strange objects or animals, which painters would then use in their work to astonish or as decoration. Colonial expansion in the 19th century enabled people to improve their knowledge of civilizations that had previously been unknown or little understood, such as Japan, Africa, the Pacific islands, even pre-Colombian culture. In the major European cities exhibitions were held, and books and periodicals devoted much coverage to the theme. Artists began to travel abroad, gaining experience of other cultures and reliving them in their work. For some it was merely a form of eclecticism, a way of acquiring different elements to use without any particular discrimination, but for others it was a genuine passion for the exotic, derived from real interest in eastern culture and from a desire for novelty. Lastly there was primitivism, or the attempt to return to the origins of human spirituality, uncontaminated by progress, to myths, symbols, and to the magical function and ritual of art.

■ Vincent Van Gogh, *Japonaiserie: Oiran (The Actor)*, 1887, Rijksmuseum Vincent Van Gogh, Amsterdam. Van Gogh copied one of the Japanese masters, Keisai Yeisen, absorbing the use of strong color contrasts.

■ *Warrior from Jalisco*, Mexico, 100 BC–250 AD, private collection. The formal simplification, which became typical of modern art, is evident in this work.

■ *Incense Burner in the form of a Jaguar*, Mexico, 450–600 AD, sold at Finarte, December 10, 1992. Lipchitz, Epstein, Moore, and Duchamp were among many artists inspired by pre-Colombian art.

■ Picasso, *Female Nude*, detail, 1907, Civico Museo d'Arte Contemporanea, Milan. This is a study for *Demoiselles d'Avignon*; her features are clearly derived from African sculpture.

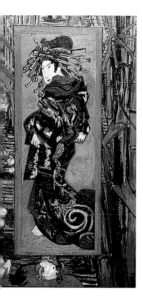

■ Gauguin, *Woman Holding a Fruit*, 1893, Hermitage, St Petersburg. Gauguin's experience of Tahiti and the Marquesas islands indicated a return to the purity of origins, away from European civilization.

A non-European aesthetic

Why did the 20th century produce such wide-ranging debate on western aesthetic ideas, which had been largely accepted without substantial modification since the Renaissance? This radical review of what constituted western art had its roots in the events that affected Europe as a whole in the first half of the 20th century. The European nations had had their political, economic and cultural dominion weakened by two world wars, leaving the United States to become the new focus. America was looked to for a pioneering spirit, a search for new frontiers, and the more liberal attitudes of a cultural kind of "melting pot".

1920–1929: the painter and his model Henriette

In 1920 Sergei Diaghilev, manager of the Ballets Russes, asked Matisse to design the stage set and costumes for a new theatre production, based on the *Chant du Rossignol* by Igor Stravinsky, choreographed by Léonide Massine. In June, Matisse visited London, to attend performances at Covent Garden. On his return from England, he spent several weeks at Etretat, on the Normandy coast, where Courbet, Monet, and other painters had also stayed. At the end of the year he exhibited 31 paintings produced at Etretat at Bernheim-Jeune, as well as 21 painted at Nice the previous year and two still lifes from 1890, which he called *My First Picture* and *My Second Picture*. On December 10, 1923 his daughter Marguerite married the art critic Georges Duthuit. In February and March of the following year he exhibited at the New York gallery of Joseph Brummer, who had been a pupil at the Académie Matisse in 1908. In the same year Leo Swane organized a wide-ranging retrospective in Copenhagen. In December Joseph Brummer welcomed Pierre Matisse, who intended to take up a career as an art dealer in New York. In the summer of 1925 Matisse senior spent some months in southern Italy. In 1927 Pierre Matisse organized a show at the Valentine Dudensing gallery in New York. Not long afterwards, Henri Matisse was awarded first prize at the Carnegie International Exhibition in Pittsburgh.

■ Matisse, *Henriette II*, 1927, Musée Matisse, Nice. Born in 1901 in Dunkirk, Henriette Darricarrère lived in Nice with her parents and two brothers, close to the apartment of Matisse. The artist had met her in 1920 at the Studios de la Victorine, when she had a dancing role in a film.

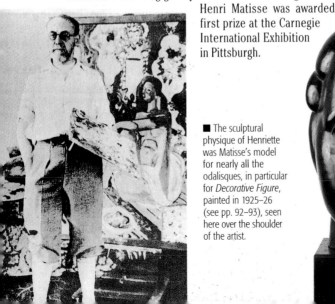

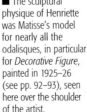

■ The sculptural physique of Henriette was Matisse's model for nearly all the odalisques, in particular for *Decorative Figure*, painted in 1925–26 (see pp. 92–93), seen here over the shoulder of the artist.

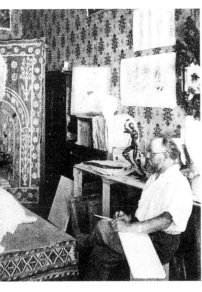

■ Matisse was struck by the strong but sweet features of Henriette, who agreed to pose for him from 1920 to 1927.

He encouraged her to dance, to play the piano and the violin, and taught her the techniques of painting.

■ Matisse, *Portrait of Henriette*, 1920, Musée Matisse, Nice. This is one of many charcoal drawings, used by Matisse as a starting point for lithographs, sculptures, in particular a series of three bronzes, and paintings, from the odalisques to the equally successful series of Spanish women.

■ Matisse, *Woman with a Veil*, 1927, WS Paley collection, New York. Of all his models, Henriette was the one who enabled him to achieve what the artist called "the almost complete identification of the artist with his model".

Woman with Mandolin at the Window

Woman with Mandolin at the Window, 1921, Musée de l'Orangerie, Paris. Although the canvas displays a number of elements dear to the artist, frequently seen in his paintings, the approach here is unusually intimate and reflective.

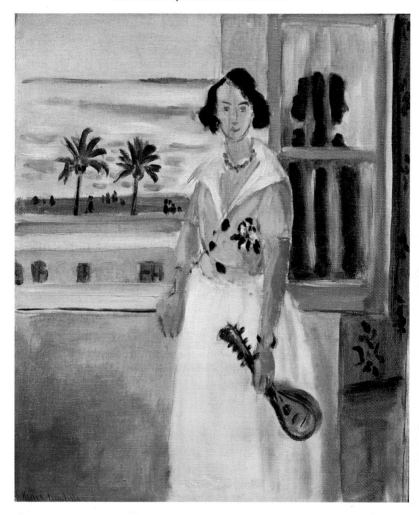

■ Matisse often returned to the theme of the window. Studying a point of contact between interior and exterior brought him closer to the theories of the Futurists, which the artist would have known about through his acquaintance with Gino Severini, in Paris, around 1910. The desire to reinvent the traditional approach to space had led the Futurists to speculate on the theory of "simultaneity", a synthesis of near and far, inside and outside.

■ The model is posed in a natural, informal manner, looking directly at the spectator, unsurprised at being observed. Her expression conveys a mood of quiet, calm serenity. Her reflection in the glass anticipates the cutout silhouettes the artist was to produce in the fifties.

■ The mandolin in the foreground is another reminder of Matisse's love of music. "It's true, music and color have nothing in common, but they follow parallel paths", he wrote in 1945. "Seven notes, with some light modification, are enough to write any musical score. Why should the same not happen with art?"

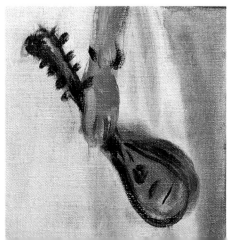

1930–1939: from Tahiti to the scenery for "Rouge et Noir"

From February 27 to July 31 1930 Matisse embarked on a long visit to the United States and Polynesia (Tahiti and Tuamotu). From September 14 to the beginning of October he was in America again, visiting museums and meeting some of his most important collectors, in particular Albert Barnes, who asked him to create a mural decoration for his Foundation at Merion Station, near Philadelphia. It was to be very large, made up of three panels about 4 m (13 ft) high and nearly 5 m (16 ft) wide. The chosen theme was Dance, and the figures were reduced to abstract symbols, in a succession of curving lines and delicate chromatic shading. By mistake the first version (now in the Musée National d'Art Moderne, Paris) was the wrong size, so between 1932 and 1933 he created a second, which absorbed nearly all his time. At the end of 1938 he left Place Charles Félix and moved to the Hôtel Excelsior Régina, in the Cimiez hills.

■ In 1938–39 he worked with Massine to produce the stage set and costumes for the ballet *Rouge et Noir* by Shostakovich, presented at Monte Carlo, New York and Paris.

■ Matisse, *Lady in Blue*, 1937, National Museum of Modern Art, Kyoto. This is one of numerous variations on the theme of the human figure against a decorative surface.

■ In 1935–36 Matisse made a cartoon drawing for a tapestry, *Window in Tahiti* (Musée Matisse, Nice), taken from a drawing made in his room at the hotel where he was staying.

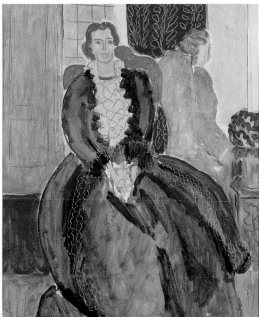

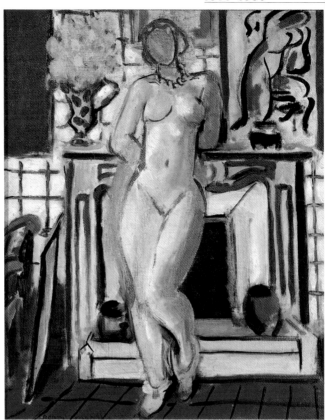

■ Matisse, *Nude in front of a Hearth*, 1936, Berggruen collection, Geneva. In the thirties Matisse made numbers of drawings and paintings depicting female nudes, in various poses and with different color and stylistic results. He started with a first sketch which he would then work up, studying the rhythm and volumes of the human figure in relation to the other objects shown.

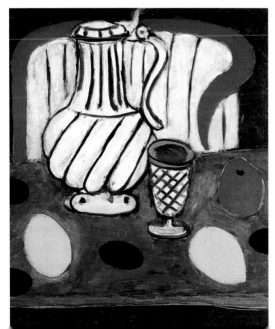

■ Matisse, *Still Life*, 1939, private collection. At the end of the thirties Matisse returned to painting still lifes. At this time, when he was working hard on an overmantel decoration for Nelson Rockefeller, the elements in his compositions were flattening out to the point of two-dimensionality and the colors were becoming brighter, pointing the way to his last work, the découpages.

Lithography and etching

This lithograph of 1925, *Large Odalisque in Striped Trousers*, depicting Henriette Darricarrère, is without doubt his most famous, for its great expressive force and the extraordinary mastery of drawing technique.

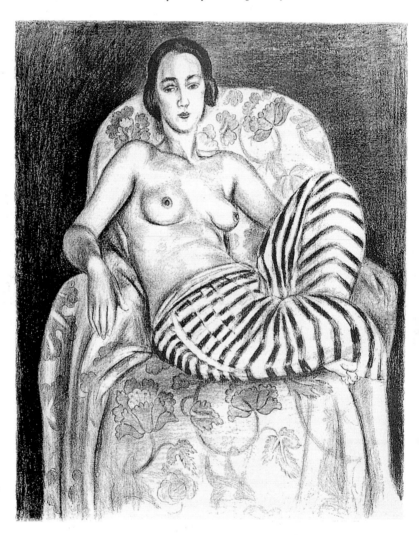

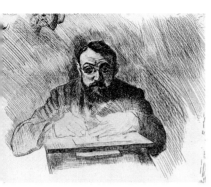

■ From 1906 onwards Matisse devoted himself with passion and dedication to lithography, producing a series of rapidly drawn, spontaneous studies. Subsequently his work was further enriched by the addition of decorative motifs derived from his paintings, while the chiaroscuro became more intense and precise, acquiring intensity and depth, as in this *Torse à l'aiguière* (sold at Finarte, March 15, 1994), printed in 1927 on China paper. Fifty prints were made.

■ Matisse started engraving on copper between 1900 and 1904. This self portrait was one of his first attempts and can be seen as a homage to Rembrandt, whose example inspired him in his early years. Matisse later discovered the woodcuts of Gauguin and Vallotton, but only produced four of his own.

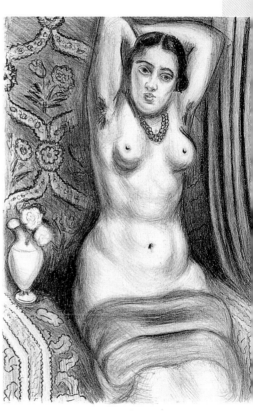

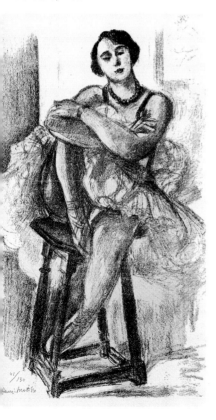

■ *Ballet Dancer*, 1927, private collection. This lithograph was part of a series called *Ten Dancers*, inspired by the work carried out for Diaghilev's Ballets Russes. As well as etchings and lithographs, Matisse experimented with other techniques with success, for example a series of 60 monotype prints made between 1914 and 1916; linocuts after 1938; and various portraits in aquatint in the forties.

"Minotaure" magazine

A young and enterprising book-lover named Albert Skira, who founded a publishing house of the same name in Lausanne in 1928, appeared on the scene on October 25, 1931, when he published an illustrated version of Ovid's *Metamorphoses*; the work contained 30 etchings by Pablo Picasso. A year later Mallarmé's *Poésies* were published, the first book designed and illustrated by Matisse, with 29 original etchings. In 1933 Skira, with the assistance of Efstratios Tériade, appointed André Breton to edit *Minotaure*, a new arts magazine. It was initially a mouthpiece for the Surrealists, but Breton, shrewd and open-minded, made room for debate between artists of varying opinions and tendencies, from Braque to Derain, Laurens to Brancusi. Innovative in every way, including in its design, the magazine published the first writing by Lacan, studies by Pierre Mabille on anthropology and the unconscious, articles by Michel Leiris on black art, and photographs by Man Ray and Brassaï. The last issue appeared in May 1939, after which the political situation prevented it continuing. Its life was short, but *Minotaure* was important for the development and diffusion of the avant-garde in art, and constitutes a fundamental record of art between the wars.

■ Picasso designed the cover for the first issue of *Minotaure*; Matisse that of 1936, his first illustrated cover. The other covers were by Duchamp, Miró, Dalí (1936), Magritte (1937), Max Ernst (1938), and Masson (1939).

■ The title *Minotaure*, suggested by Masson and Georges Bataille, derived from the growing interest in the psychoanalytical interpretation of the myth. The labyrinth, the recesses of the mind, has at its center the Minotaur, symbol of irrational impulse, killed by Theseus, or the conscious mind.

■ Matisse is shown here checking the printing of one of his lithographs. After Mallarmé's *Poésies*, the most significant Skira publication illustrated by Matisse was *Florilège des Amours de Ronsard*, published in 1946, with 126 original lithographs.

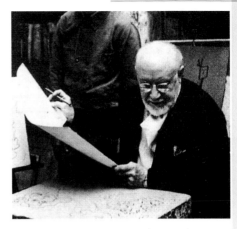

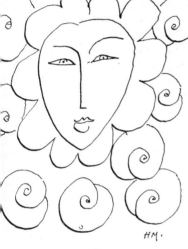

■ In 1948 Matisse designed the cover for the catalogue marking the 20th anniversary of the Skira publishing house, and the design went on to become an unofficial trademark.

■ Matisse's dedication to Albert Skira, "the king of editors", in 1946. The occasion was the publication of Pierre Reverdy's book, *Visages*, illustrated with 14 lithographs.

■ Skira, shown here in 1973, the year of his death, together with Picasso, is regarded as the creator of modern illustrated art books. He combined choice authors, the most important critics of the time, elegance of design and printing precision, particularly in the quality of the color plates.

VISAGES

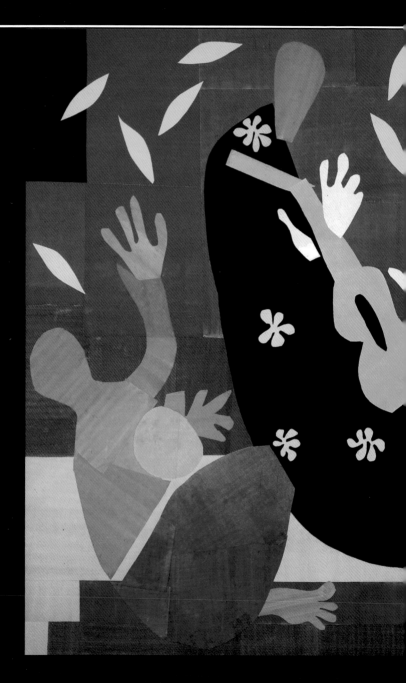

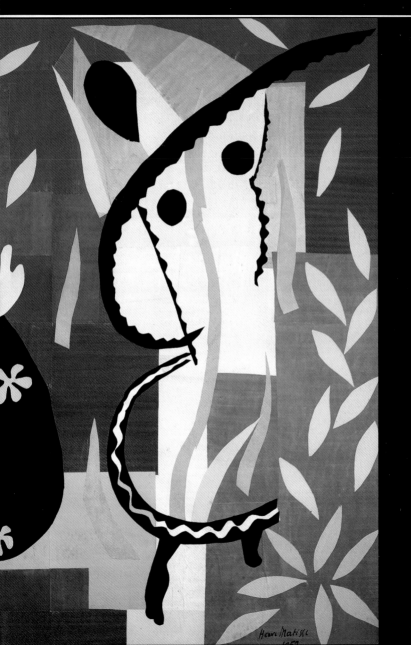

1939–1945:
the war

On September 1, 1939 World War II broke out. Matisse was in Paris, but after a brief trip to Genoa to see an exhibition of paintings from the Prado, he moved to Cimiez. In May 1940 he returned to Paris, just at the point when the Germans had broken through the Franco-British defences. He wondered whether to go to Brazil and his son Pierre urged him to come to the United States, but after trying various places in France, he decided to remain on the Côte d'Azur. Apart from the war he was troubled by his deteriorating relationship with his wife, and the couple separated formally, on the advice of art dealer Paul Rosenberg. Meanwhile his health was worsening and on January 10, 1941 he underwent an operation for a duodenal tumour at the hospital in Lyons. The operation was successful and in May he was strong enough to return to Nice and resume painting. Matisse had never in his life concerned himself with politics and the Vichy government allowed him to work in peace, bearing in mind his age and state of health. It was not the case with his wife and daughter, who were in Toulouse, where they had worked with the Resistance. In 1944 they were arrested by the Gestapo: Amélie spent six months in prison; Marguerite was put on a prison-train destined for the concentration camps in Germany, but was liberated by the Allies.

■ Henri Cartier-Bresson, *Matisse drawing a Flower at Vence*. In 1943 the war in North Africa began to threaten the coast of the south of France. In March a number of air raids over Cimiez persuaded Matisse to move inland, to Vence, where he remained until the beginning of 1949, in a small villa called Le Rêve.

■ Matisse in a photo from early 1939, in a studio in Paris loaned to him by Mary Callery, an American sculptor.

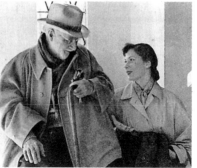

■ Matisse with his niece Jacqueline. The war years were the most tormented of his life, with family problems and illness adding to the difficulties created by the war. Yet they were also years of intense, feverish activity, during which he created some of his most significant works.

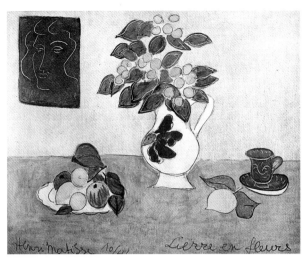

 Matisse, *Lierre en Fleurs*, 1941, Lasker collection, New York. After the operation, despite predictions that he only had a few more months to live, Matisse felt reborn and devoted himself to painting with renewed energy.

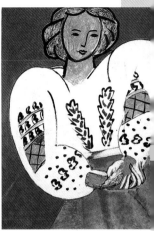

■ Matisse, *The Dream*, 1940, Musée National d'Art Moderne, Paris. Between 1937 and 1940 his models were asked to wear "a lovely old Romanian blouse with faded red *petit point* embroidery that must have belonged to a princess".

■ Matisse took nearly a year to paint *The Dream*, which he finished in 1940 (private collection). The last of the various models who posed for this painting was Nezy Hamide Chawkat, great-granddaughter of the last Ottoman Sultan Abdulhamid II, who had recently emigrated to Nice.

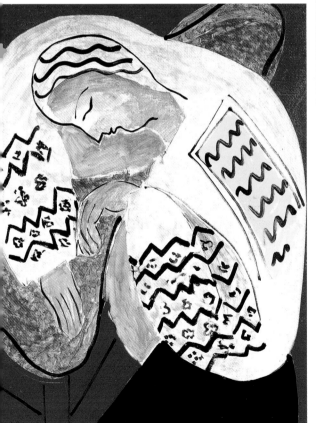

Still Life with Magnolia

Among the many still lifes painted in Nice after his spell in hospital, *Still Life with Magnolia* (1941, Musée National d'Art Moderne, Paris) is one of the most precise, with careful placing of objects and distribution of color.

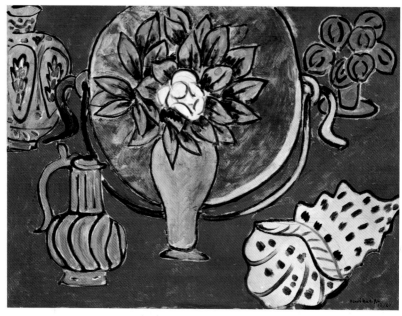

■ The jug handle repeats the motif of the handles of the cauldron which surrounds the magnolia like a flaming halo. Similarly the curved lines of the rounded sides echo the curved lines of the snail and the green vase. The strong light brings out the bright colors and is diffused in a uniform, direct manner, without shadowing or chiaroscuro. The whole composition therefore appears to be weightless and two-dimensional, flattened against the red background.

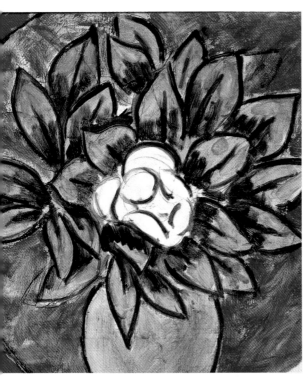

■ The constant presence of flowers and leaves has been interpreted as a living representation of *élan vital*, or the vital impulse which moves and animates nature and also human creativity, as expressed in *L'Evolution Créatrice* by Henri Bergson. Matisse had met the philosopher in 1910, after discussion with Matthew Stewart Prichard, an ex-pupil of Bergson. In 1914, not entirely uncoincidentally, Matisse etched a portrait of his friend Prichard, showing him surrounded by magnolias.

■ Alfred Barr, in his monograph on Matisse, noted the symmetry with which the objects are arranged, and compared the composition to a "Quattrocento altarpiece, with the Madonna surrounded by four saints". Jacqueline Duhême recorded that Matisse "liked to be surrounded by objects positioned in a very precise manner. They had to be placed where he wanted them. After a vase on a piece of furniture had been dusted, it had to go back in exactly the same position. Nothing around him was casually put down."

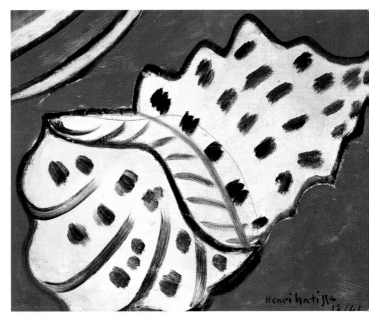

1940–1954

Eroticism old
and new

From the first sculptures of the Stone Age right up to the present day, the female form has always been the symbol of beauty par excellence. Painters and sculptors of every era and every latitude have dedicated the best of their talents to the female figure, exalting her as a well of pleasure and source of life or condemning her as temptress and sinner. The eroticism of Matisse derived directly from the origins of painting, from the goddesses depicted in the rooms of the Pyramids, to the celestial Venus of ancient Greece, through to the solid, full forms of Michelangelo, Titian and Rubens, up to Renoir and Cézanne. Matisse gave new force and vigour to the classic elements of the western tradition, adding an exotic atmosphere borrowed from Oriental iconography and from primitive African and Oceanic art. He left behind the traditionally-depicted nudes of the 19th century and offered a new way of understanding the female, in a manner that was taken up by many artists in this period. His nudes, including the odalisques, express a serene, joyous sensuality. Utterly content and free from care, they offer themselves to the onlooker without shame, unaware of guile, or seduction, almost as though their world (whether the unspoilt nature of *Bonheur de Vivre* or the domestic scene of the painter's studio), inhabits a time before original sin or long after redemption.

■ Wesselmann, *Study for Bedroom Painting (Daniele)*, 1971, sold at Finarte, March 9, 1995. The American artist expands space with the physicality of the figure and the objects, emphasizing form and color and giving them a role of obsessive responsibility, typical of our mass media society.

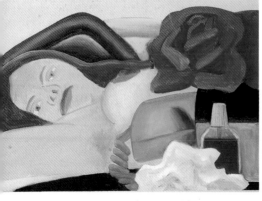

■ Modigliani, *Reclining Nude with Open Arms*, 1917, private collection. From December 3 to 30, 1917, Modigliani held his first show at the Berthe Weill gallery in Paris. The scandal provoked by the five nudes was such that the Prefect of police ordered their withdrawal, "as an outrage to modesty".

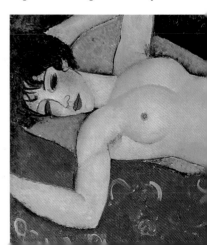

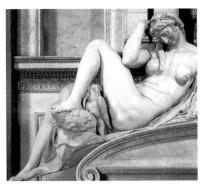

■ Michelangelo, *Night*, 1526–31, Basilica di San Lorenzo, Florence. Matisse loved Italian art and studied it in French museums and on his travels to Italy. He was inspired by the Tuscan masters, from Fra Angelico to Michelangelo and greatly admired Venetian painters, especially Titian and Tintoretto.

■ Matisse, *Pink Nude*, 1935, Museum of Art, Baltimore. A series of 22 photos documents the lengthy gestation of this painting. The first version was much more realistic, then, with each subsequent version, he simplified the pose and contours of the model and turned the objects in the background into abstract figures.

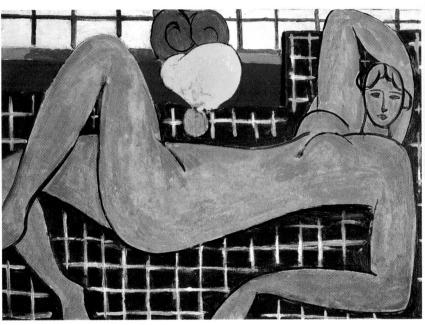

Between innovation and unification

Matisse was not a revolutionary, but an innovator; he did not reject the pictorial tradition which had gone before, but instead studied it with humility and respect: he assimilated and reinvented it, adding his own personal view. Similarly, when he had the chance to study elements which were foreign to his own culture, he did not select only those elements which were compatible with each other. He confronted different ways of thinking with an open mind, analyzing the fundamental aspects, trying to understand, and trying to blend them into a new whole, even if this meant following an incoherent, uneven path. He was not afraid of experimenting with new technical or stylistic solutions nor afraid to abandon them if he was dissatisfied.

113

1946–1950: Matisse the draughtsman

Peace was declared at the end of 1945, and a major exhibition was organized in celebration at the Victoria and Albert Museum in London, with works by Matisse and Picasso. The show was repeated in 1946 in Brussels. In the meantime, in February, the Union Méditerranée pour l'Art Moderne de Nice organized a show of his latest work, and to celebrate 20 years of residence on the Côte d'Azur, he was nominated as co-president of the Union along with Bonnard. In the same year Matisse appeared in two film documentaries. In the first, *L'Art Retrouvée*, he played a minor role, but the second, titled *Matisse*, was entirely dedicated to the artist and his paintings. In 1947 he was awarded the Légion d'Honneur (he had been made a Chevalier in 1925) and some of his paintings were acquired by the new Musée National d'Art Moderne in Paris. In January 1949 he left Vence and returned to the Hôtel Régina, where he was able to work in greater comfort, in two large rooms specially prepared for him. Matisse celebrated his 80th birthday at the Hôtel on December 31.

■ Matisse, *Woman Writing*, 1918, private collection. His drawings, one moment schematic, the next richly detailed, reveal his working methods and emphasize the long and patient preparation which preceded the paintings.

■ Matisse, *Portrait of Annelise*, 1946, sold at Finarte, December 21, 1994. His drawing technique was not very different from the École des Beaux-Arts tradition, which he had adopted himself during the era of his Academy. It shows a genuine love for the ancient, visible even in his most innovative works.

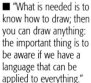

■ "What is needed is to know how to draw; then you can draw anything: the important thing is to be aware if we have a language that can be applied to everything."

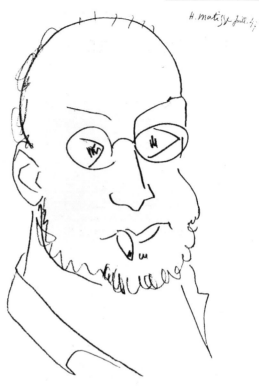

H. matisse juill. 47

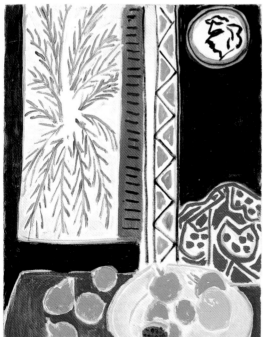

■ In the forties, with his health problems seemingly overcome, Matisse returned to drawing with vigour, concentrating on his models and his friends, or else on ironic self portraits, like this one from 1947.

■ Matisse, *Still Life with Pomegranates*, 1947, Musée Matisse, Nice. In this Vence interior Matisse returns to the theme of the window, here filled with dense foliage, transforming it into an abstract decorative element. The medallion (top right) is reminiscent of one he painted in 1890 with a portrait of Caroline Joblaud.

MASTERPIECES

Asia

Asia, 1946, Kimbell Art Museum, Fort Worth, Texas. The use of an allegorical figure is rare in Matisse's work and has a single precedent, *La France*, painted in 1939, now on display in the Museum of Art in Hiroshima.

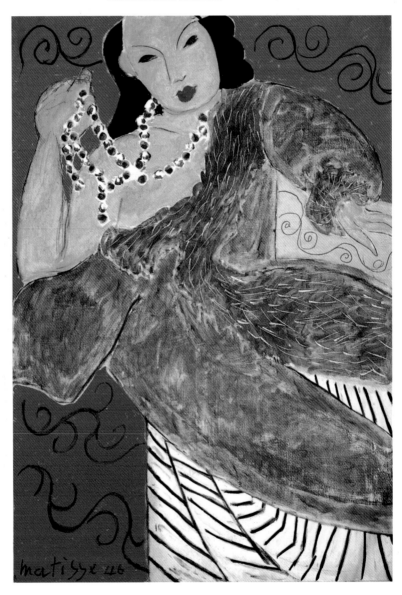

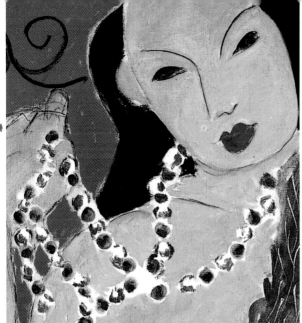

■ The artist has spread color with wide, even brushstrokes, alternating with little dabs of white and black, which give movement and depth. The asymmetrical position of the woman, whose forehead "protrudes" from the upper frame, gives the impression that the figure is leaning forward, driven by the red background and by her own black hair. The facial features echo the drawing on page 114, but the face has been made to look more oriental.

■ This detail shows the hands, which Matisse regarded as the real test of an artist, by which he would judge immediately whether someone had talent or was merely a modest craftsman. This is what he called "the Burmese hand"; it resembles a flower and turns into a pure arabesque.

■ The entire picture is dominated by these decorative motifs, which represent a homage to the Oriental tradition of calligraphy. The shapes lose their identity, first becoming signs, then, little by little, dematerialising until there is free play of lines in movement and they become pure decoration.

Book illustration

The 1940s saw the definitive arrival of illustrated books, thanks to advances in printing techniques and also to the inventiveness of two inspired publishers, Skira and Tériade, worthy successors to Vollard. One of many artists involved, Matisse became one of the key players because of the almost fanatical precision with which he followed every production stage. He had already, in 1918, provided 5 drawings for *Les Jockeys Camouflés* by Pierre Reverdy; in 1932 he produced at least 52 etchings, of which 29 were chosen for Mallarmé's *Poésies*. Three years later he made six etchings for James Joyce's *Ulysses*, interpreted with sensitivity. The most productive, busiest phase ran from 1946 to 1950: the *Pasiphaé* of Henri de Montherlant in 1944; in 1946 *Visages* by Pierre Reverdy and *Lettres Portugaises* by Marianna Alcaforado; the following year *Repli* by André Rouveyre, Baudelaire's *Fleurs du Mal* and *Jazz*, his masterpiece. In 1948 he illustrated *Florilège des Amours de Ronsard* and in 1950 *Les Poèmes de Charles d'Orléans*, as well as other publications in which he did not have a direct role, but supplied drawings and etchings. These included *Le Signe de Vie* by Tristan Tzara, covers for arts magazines (*Minotaure, Verve, Roman* etc) and catalogues for his shows. With rare exceptions he did not draw inspiration from his paintings, but adapted his style and sensitivity to the text, aiming for a visual representation of its content.

■ Matisse, seated on a wheelchair to save him expending energy, at work on his découpages in his studio at the Hôtel Régina.

■ In 1944 the Parisian publisher Martin Fabiani published *Pasiphaé: Chant de Minos*, with 18 linocuts, a cover and other details by Matisse. The artist experimented with a technique which was new to him, aware of the need to develop a style that was different from painting and other types of engraving.

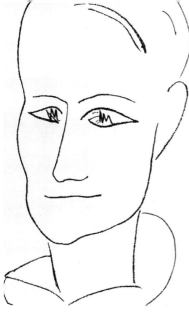

■ Matisse, *Portrait of Baudelaire*. As illustration for *Fleurs du Mal* in 1947 Matisse had initially planned 33 original lithographs, but a technical problem made the drawings unusable. Fortunately photographs, reproduced in photo-lithography, together with an etching and 69 xylographic engravings had been made.

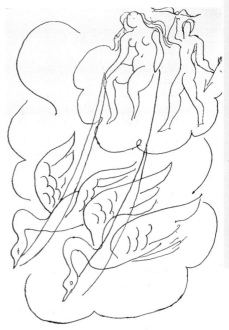

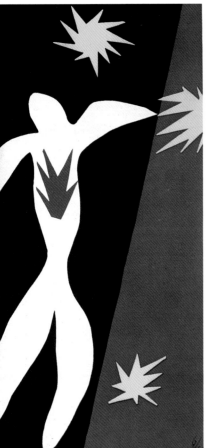

■ Matisse, *Icarus*, 1943 (published by *Verve* in 1945) marked a significant stage in the artistic development of Matisse. This was one of the first cutout gouaches not to be used as a study for other works, having its own independent value. It also constituted the starting point, both in the choice of colors, and in the organization of space, for the great *Jazz* collection.

■ One of the most complex and contro-versial books designed by Matisse was *Florilège des Amours de Ronsard*, published by Skira in 1948 after seven years of preparation, with 126 lithographs, a cover and other decorative details in the text. Alongside the understandable discomforts of war, the artist underwent frequent changes of heart, altering the images and the character of the text. Fortunately he was assisted by excellent printers, such as the Mourlot brothers.

Jazz

Published in Paris by Tériade in 1947, *Jazz* contained 152 pages of text, with Matisse's writing on the facsimile and 20 color illustrations. This edition ran to 250 copies, plus 20 which were not for sale and 100 portfolios with the plates only.

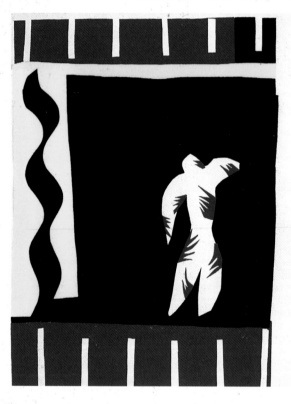

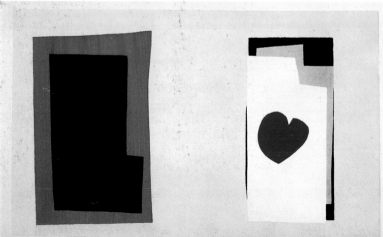

atisse

Z

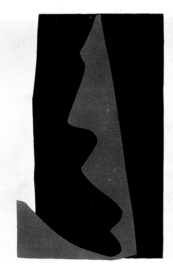

■ Some of the plates for *Jazz* maintained links, albeit slender, with reality, in particular the circus with the clown (see left), the cowboy (see p. 132), the knife thrower and trapeze artists. Other illustrations had symbolic significance, as he writes at the end of the book "they are crystallizations of memories, tales or travels".

■ In other images, as in for example, *Heart, Destiny* and those entitled *Lagoon*, with memories of his trip to Tahiti, Matisse approached Abstract art. Here he combines and blends the geometrical simplifications of Cubism with forms seen in nature, which he had already used as a decorative element.

édition

■ The text written by Matisse for *Jazz* did not have a unifying theme and was not tightly linked to the images. It consisted of poetic and philosophical reflections, in which he reaffirmed his love for music and drawing, flowers and colors, revealing his view of life, his fears and hopes for the future.

The "papiers découpés"

Matisse had begun to use *papiers découpés* in 1920, using the idea of cutout silhouettes as part of the dancers' costumes for the ballet *Le Chant du Rossignol*. He returned to the idea in 1930 when working on the decoration for the Barnes Foundation; then for the covers of issues 3 and 5 of the magazine *Cahiers d'Art* in 1936, and a year later for the first issue of *Verve* and for the ballet *Rouge et Noir*. He was now over 80 years old, and painting and carving had become increasingly difficult and tiring. A handicap was thus transformed into an opportunity for experimenting and discovering a new technique for expression. The nearest antecedents were the "papiers collés" used before the twenties by Picasso and the Cubists, the collages of Severini, Carrà and other Futurists, the Russian Constructivists, the Surrealists, and the Dadaists. There were significant differences, however, starting with materials. While the others used printed material (such as newspapers, tickets, photos), which then acquired new and different meanings according to the context, Matisse took the paper for cutting and painted it himself with tempera.

■ Matisse, *Chinese Fish*, 1951, sold at Christie's, November 7, 1995. "Here is a dugong, which is easily recognizable and, above, an animal in the form of algae. Around these are begonias".

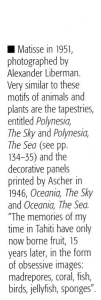

■ Matisse, *Blue Nude IV*, 1952, Musée Matisse, Nice. This was the last and the most complex of a series executed between September and June. The cutout was studied at length and the traces of charcoal left in the background show that it underwent various changes.

■ Matisse, *Creole Dancer*, 1950–51, Musée Matisse, Nice. The dancer is placed on a geometric background of bright colors. She has been painted green, as though she were a plant, with arms and legs like leaves and a face which could be a strange, exotic fruit.

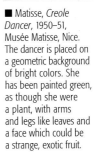

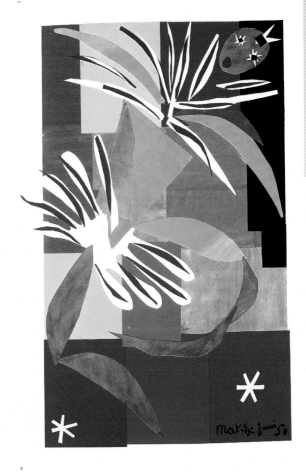

■ Matisse in 1951, photographed by Alexander Liberman. Very similar to these motifs of animals and plants are the tapestries, entitled *Polynesia, The Sky* and *Polynesia, The Sea* (see pp. 134–35) and the decorative panels printed by Ascher in 1946, *Oceania, The Sky* and *Oceania, The Sea*. "The memories of my time in Tahiti have only now borne fruit, 15 years later, in the form of obsessive images: madrepores, coral, fish, birds, jellyfish, sponges".

123

The "visages vides"

Nude, Spanish Carpet, 1919, private collection. The "visages vides" (blank or empty faces) began to appear in 1906, with *Bonheur de Vivre*, and represent one of the most characteristic aspects of Matisse's painting.

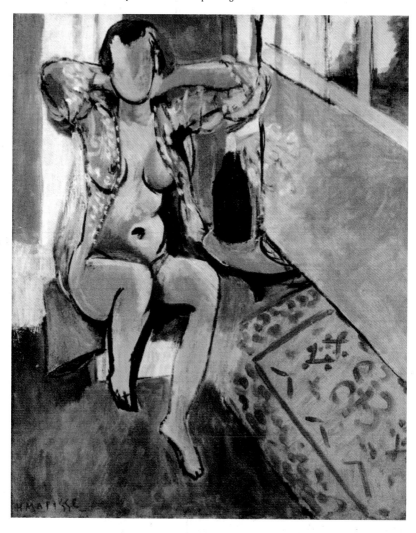

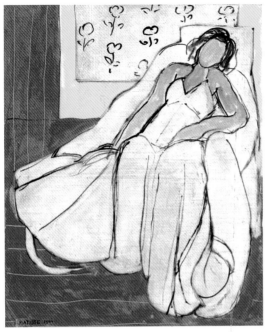

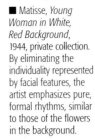

■ Matisse, *Young Woman in White, Red Background*, 1944, private collection. By eliminating the individuality represented by facial features, the artist emphasizes pure, formal rhythms, similar to those of the flowers in the background.

■ Matisse, *Michaela on Ochre Background*, 1943–44, private collection. Even if it is not possible to read a metaphysical significance into this (leaving the aesthetic aside), this iconoclastic solution is enigmatic in many ways.

■ Matisse, *Seated Pink Nude*, 1935–36, private collection. This was one of the most succinct and least decorative works, with a predominance of straight lines and indefinite color spread.

1950–1954:
the last shows

B etween 1950 and 1951 Matisse produced his last sculptures, including *Standing Nude*, and his last paintings, and devoted himself totally to cutout silhouettes. His work was increasingly recognized and appreciated by critics and by collectors, thanks to numerous shows held all over the world. In 1950 he exhibited around 50 works at the 25th Venice Biennale, where he was awarded the Grand Prix for a foreign artist; in 1951 he exhibited at the Museum of Modern Art in New York and at the National Museum of Tokyo. In 1953 the Musée Matisse was opened in his home town, Cateau-Cambrésis. He exhibited his découpages at the Berggruen gallery and was the subject of a large retrospective at the Tate Gallery in London, a show which subsequently toured various cities in the United States. On November 3, 1954, after a brief illness, Henri Matisse died in his room in Nice, at nearly 85 years old; five days later, he was buried in the cemetery at Cimiez.

■ Matisse's studio at the Hôtel Régina, photographed by Hélène Adant in 1953, literally carpeted with drawings (depicting faces and nude studies) and with cutout silhouettes painted with tempera, fixed to the wall with pins.

■ Matisse, *Memory of Oceania*, 1953, Museum of Modern Art, New York. The composition combines schematic parts and informal elements, all together on a white background. It is an enigmatic picture and there have been various critical interpretations of the details, such as the yellow shape at top left (a hand of bananas?), the boat-like shapes bottom right (pirogues?) and the charcoal outlines (a stretched-out nude?).

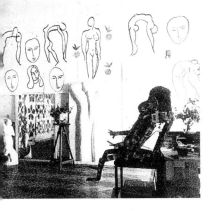

■ Shortly before he died, Matisse fastened a stick of charcoal to a long bamboo cane, and traced the smiling faces of his young grandchildren on the ceiling of his room.

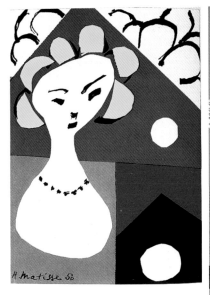

■ Catalogue cover for the show held from July to September 1950 in Paris at the Maison de la Pensée Française. Although the institution was run by Communist intellectuals, Matisse presented the first scale models for the Chapel of the Rosary at Vence.

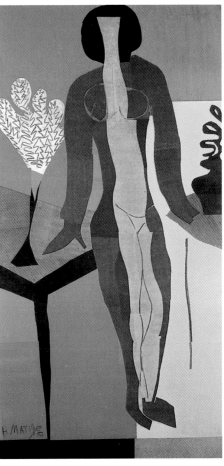

■ Matisse, *Zulma*, Statens Museum for Kunst, Copenhagen. In 1950–51, while he was finishing the decorations for the Chapel of the Rosary, he produced three important paper cutouts, *Creole Dancer* (see p. 123), *Thousand and One Nights* and this, with its graceful lines and bright colors.

1940-1954

The Chapel at Vence

The decoration for the Dominican nuns' Chapel of the Rosary at Vence, not far from the home of Matisse, absorbed the artist's working life almost completely from 1948 to 1951 and is regarded as his spiritual testament.

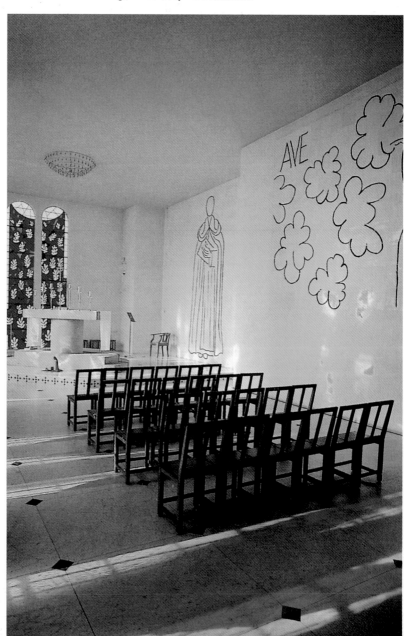

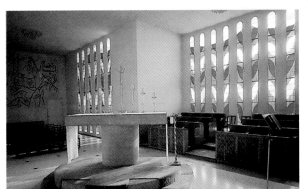

■ Matisse conceived his idea in December 1947, following a series of meetings with Sister Jacques-Marie, a former nurse whom he had met at the hospital in Lyons, and with two Dominican monks, Brother Rayssiguier, who became his assistant in the architectural project, and Brother Couturier, who promoted the cause of religious art after the war.

■ Matisse's central preoccupation was with the light, which enters the chapel filtered by large windows of opaque and transparent stained glass.

■ The huge panels painted in black onto walls of white ceramic depict St Dominic, the Madonna and Child and the Stations of the Cross.

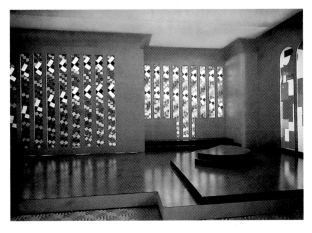

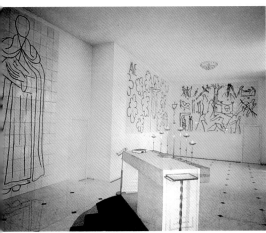

■ The artist also designed the liturgical accessories, the crucifix and candle holders in bronze, the ciborium, the tabernacle, and various surplices and chasubles, for which he produced 22 designs, using the cutout technique and drawing on Byzantine models.

The legacy of Matisse

Forty years after the death of Matisse, his teaching is more alive and present than ever. Art historians regard him as one of the absolute key figures of this century and many of his pictures have firmly entered the collective imagination. For decades his works have formed part of the major private collections and the most important museums, and almost every year retrospectives are organized, either on a broad scale or focusing on one of the many aspects of his productive life. The most well-known aspect of his work, the use of color and drawing as a decorative element, has been absorbed and appropriated in recent years by followers of Pop Art and by graffiti artists, with the idea of attracting attention and communicating with immediacy and imagination. Others, however, have been inspired by his return to primitive art, by works directly or indirectly inspired by the Orient, by the sensuality of the odalisques or the graceful quality of his still lifes; by the solid composure of the sculptures or the animation of the découpages. More generally, artists have seen in him the last great artist capable of studying the ancients and their skills, in order to reinvent and adapt them for new sensibilities, and have tried to recreate in their own work their own "joie de vivre".

■ Haring, *For Claudia*, 1983, private collection. Keith Haring died early, at the age of 32, in 1990. He went from painting subway trains to major international exhibitions in the space of a few years.

■ Warhol, *Vesuvius*, 1985, sold at Finarte, April 14, 1992. American Pop Art, which counts Andy Warhol as one of its most talented interpreters, marked the definitive move from European art to American art, which still remains a synthesis of avant-garde movements from the Old World.

■ Warhol, *Flowers*, 1964, private collection. The vivid colors and simplified forms are very reminiscent of the découpages of Matisse.

FOR CLAUDIA

■ Haring, *Figure*, 1983, sold at Finarte, December 14, 1993. Born as a protest movement in the poor suburbs of large American cities, "graffiti art" revolutionized contemporary art, reinventing its colors and forms.

■ Chia, Clemente, Cucchi, De Maria, and Paladino are the exponents of trans-avant-garde. The statuesque placing of this *Seated Figure*, the work of Sandro Chia in 1989 (sold at Finarte, December 19, 1991) echoes *Decorative Figure* by Matisse (see p. 92).

How much for a Matisse?

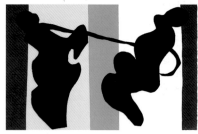

W̲ere he to be quoted on the Stock Exchange, Matisse would definitely be a "blue-chip" investment, in other words a guide share price to which other investors refer. His work frequently appears in galleries and at auctions all over the world, commanding high prices. His graphic art is naturally more affordable and lithographs can be bought for $US1–3,000, up to $US240,000 for *Grande Odalisque à la Culotte Bayadère* (see p. 102; Sotheby's, November 8, 1995). A Matisse drawing would fetch a minimum of $US8–10,000 while the pastels and the cutout silhouettes sell for over a million US dollars. The same goes for the sculptures, sold for $US30–50,000, but with peaks, as in the nearly four million US dollars fetched by *Decorative Figure* (Sotheby's, May 17, 1990). However, the record prices are those paid for the paintings, from *The Hindu Pose* to the *Yellow Harmony* of 1927 ($US13,200,000 at Christie's, November 11, 1992), from *Woman with Red Parasol* of 1920–21 ($US11,250,000 at Sotheby's, October 18, 1989) to *Asia* of 1946 ($US10 million, at Sotheby's, November 10, 1992).

■ Among the portfolio series made by Matisse, *Jazz* (pp. 120–21) was without doubt the most commercially successful. Regularly seen at the major auction rooms, the complete series of 20 stencils fetches, depending on the type of edition and its state of conservation, $US100–500,000.

■ Matisse, *Chinese Fish*, 1951. This papier découpé (see pp. 122–23) was sold by Christie's in New York, on November 7, 1995, for $US5,800,000.

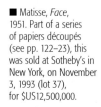

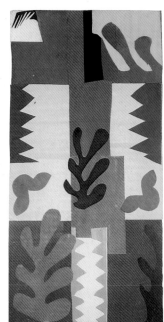

■ Matisse, *Face*, 1951. Part of a series of papiers découpés (see pp. 122–23), this was sold at Sotheby's in New York, on November 3, 1993 (lot 37), for $US12,500,000.

■ Matisse, *The Two Women*, 1938, one of the most characteristic examples of the "visages vides" (pp. 124–25) was sold in New York, at Christie's, on November 7, 1995 (lot 48), for $US5,800,000.

■ On May 8, 1995, *The Hindu Pose,* painted in 1923, was offered at Sotheby's in New York (lot 23), one of the loveliest canvases from the series of odalisque paintings (pp. 88–89). The knock-down price was $US13,500,000.

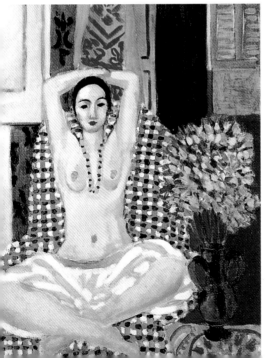

The new buyers

Until the last century, artists were employed by the Church or by aristocratic families. Then the commercial art dealers came onto the scene, and their role gradually became more important until they were monopolizing art itself. Shows were the only way for a young, emerging artist to be brought to the notice of critics and the press. Dealers often formed associations to increase audience size, through the distribution of catalogues and participation in fairs, national and international. The consequences are evident: today a work of art is seen as a commodity, subject to the laws of the market, placing a limit on an artist's freedom of expression.

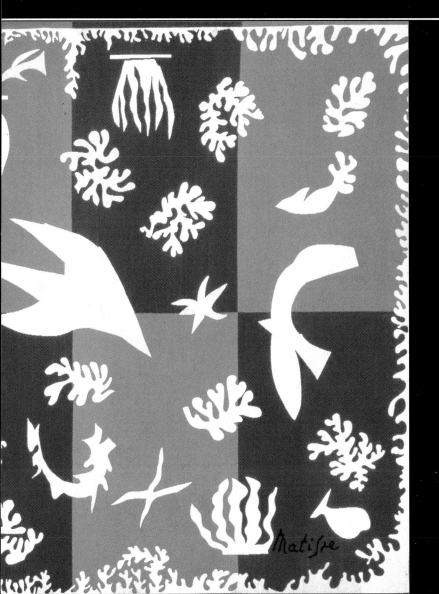

■ Matisse, *L'Eschimese*,
1947, Kunstindustimuseet,
Copenhagen.

Note

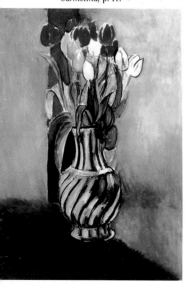

■ Matisse, *Tulips*, 1914,
private collection.

■ Matisse, *Vase with Two Handles*, 1907, Hermitage, St Petersburg.

■ Matisse, *The Moroccans*, 1915–16, Museum of Modern Art, New York.

Note

*All the names mentioned
here are artists, intellectuals,
politicians, and businessmen
who had some connection with
Matisse, as well as painters,
sculptors, and architects who
were contemporaries or active
in the same places as Matisse.*

Apollinaire, Guillaume (Rome,
1880 – Paris, 1918), French poet,
writer and critic. Constantly at the
centre of discussions on avant-
garde art of the 20th century, he
was the first to support the
Fauves, presenting their work
to the public in 1908, p. 53.

Arnoux, Antoniette, one
of Matisse's models, p. 81.

Barnes, Albert (Philadelphia,
1872 – 1951), American collector
who asked Matisse to create
mural decorations for his
Foundation, pp. 100, 122.

Bénédite, Léonce, director
of the Musée du Luxembourg. He
bought *Odalisque in Red Harem
Pants* for his museum, p. 88.

Bonnard, Pierre (Fontenay-
aux-Roses, 1867 – Le Cannet,
1947), French painter who was
one of the Nabis group, pp. 80, 114.

Bouguereau Adolphe-William
(La-Rochelle, 1825 – 1905),
academic and eclectic artist. He
was Matisse's first art teacher at
the Académie Julian, p. 10.

Braque, Georges (Argenteuil,
1882 – Paris, 1963), French artist.
He was one of the most important
exponents of Cubism, pp. 46, 47,
70, 71, 104.

Bruce, Patrick (Long Island,
1881 – New York, 1937), American
artist and great supporter
of Matisse, pp. 56, 57.

Brummer, Joseph, pupil of
Matisse at the Académie Matisse,

he later became an important art
dealer in New York, p. 96.

Camoin, Charles (Marseille,
1879 – Paris, 1965) French artist.
A pupil of Moreau alongside
Matisse, he was a follower of the
Fauve movement. His work,
however, is not characterized by
the strong coloring typical of the
group, pp. 24, 48, 64, 70.

Carrière, Eugène (Gournay,
Seine et Oise, 1849 – Paris,
1906), French artist who founded
the Societé Nationale des Beaux-
Arts. Matisse studied for a while
at the Académie Carrière, p. 24.

Cézanne, Paul (Aix-en-Provence,
1839 – 1906), French painter
whose work is characterized by a
detailed study of synthesis and
the essence of form and space.
Matisse greatly admired him and

■ Georges Braque,
Still Life: Le Jour, 1929,
National Gallery of Art,
Washington.

treasured the lessons learned from him, pp. 13, 18, 23, 24, 29, 38, 39, 42, 43, 46, 56, 112.

Chawkat, Nezy Hamide, Matisse's model, she was the great granddaughter of sultan Abdulamid II who emigrated to Nice in the 1940s, p. 109.

Darricarrère, Henriette, Matisse's model, who posed for him until 1927, pp. 83, 96, 97.

Delacroix, Eugène (Carenton-Saint-Maurice, 1798 – Paris, 1863), French artist who expressed his Romanticism through the dynamic surge of his pictures. After travels in Morocco and Algeria, he developed a rich and exotic vein in his work. His preoccupation

with light and color is evident in his later paintings, pp. 64, 88, 90.

Derain, André (Chatou, 1880 – Garches, 1954), French painter who met Matisse in 1901 at the school of Eugène Carrière. Initially one of the Fauves, he later developed an increasingly realistic style, pp. 24, 25, 34, 35, 40, 42, 43, 55, 70, 76, 104.

Diaghilev, Sergei (1872–1929), Russian artistic director, who, in 1911, started up the ballet troupe Ballets Russes, which went on to major success. His collaborators included the best dancers and choreographers, and the most famous musicians and painters of the time, among them Matisse, pp. 96, 103.

Dufy, Raoul (Le Havre, 1877 – Forcalquier, 1953), French painter. An excellent draughtsman and delicate colorist he was one of the Fauves and depicted the society of his time with grace and delicacy, pp. 37, 46, 82, 83.

Duthuit, George, art critic who married Marguerite, Matisse's daughter, in 1923, p. 96.

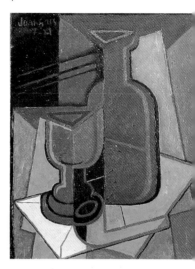

Friesz, Achille-Emile-Othon (Le Havre, 1879 – Paris, 1949), French artist who was a member of the Fauves. In his later paintings, he sought to return to the study of volumes typical of Cézanne, pp. 40, 46.

Gauguin, Paul (Paris, 1848 – Marchesas Islands, 1803), French artist whose style, characterized by an extraordinary figurative richness, influenced the Nabis and anticipated Expressionism in many ways, pp. 23, 26, 38, 42, 46, 50, 51, 56, 73, 102.

■ Gustave Moreau, *Hesiod and the Muse*, 1891, Musée d'Orsay, Paris.

■ Auguste Renoir, *Young Girls at the Piano*, 1892, Musée d'Orsay, Paris.

Picasso, Pablo (Malaga, 1881 – Mougins, 1973), Spanish sculptor and painter. After various phases in his development (the Blue and Rose periods), study of Cézanne and African art produced *Les Demoiselles d'Avignon*, the work which resulted in the birth of Cubism. He followed the varying artistic tendencies of contemporary art, from the classicism of the 1920s to the Surrealism of the 1930s. He produced numerous sculptures in bronze or made from recycled everyday materials. Towards the end of his life he devoted himself to ceramics and engraving, pp. 46, 54, 55, 70, 75, 80, 82, 83, 94, 104, 105.

Purrmann, Hans, German artist who belonged to the Berlin Sezession and was a director of the Académie Matisse, pp. 56, 57, 64.

Puy, Jean (Roanne, 1876 – 1960), French artist and a friend of Matisse and Derain, he was influenced by Gauguin and the Nabis, and exhibited with the Fauves, pp. 24, 40, 70.

Renoir, Pierre-Auguste (Limoges, 1841 – Cagnes-sur-Mer, 1919), French Impressionist painter who took the realism of Courbet and added a predilection

for subjects from everyday life, studying in particular the effects of light, pp. 80, 90, 112.

Reverdy, Pierre (Narbona, 1889 – Solesmes, Sarthe, 1960), French poet. Considered the forerunner of Surrealism, he founded the magazine *Nord-Sud*. His book *Visages* was illustrated by Matisse, p. 105.

Rockefeller, Nelson (Bar Harbor, Maine, 1908 – New York, 1979), son of the American industrialist John Davidson, who set up the Rockefeller Foundation in 1913. Nelson went into politics and became vice president of the USA during the presidency of Gerald R Ford, p. 101.

Rodin, François-Auguste-René (Paris, 1840 – Meudon, 1917) French sculptor of the Romantic school. He was greatly struck by the work of Michelangelo, from whom he derived the vigorous plasticity of the figures and the technique of the "unfinished", pp. 16, 17.

Rosenberg, Paul, French dealer. In 1915 he bought Matisse's *Still Life after Davidsz. de Heem's "La Desserte"*, p. 15.

Rouault, Georges (Paris, 1871 – 1859), French artist and pupil of Moreau along with Matisse, Marquet, and Manguin. Initially interested in the Fauves, his work was highly expressive, often suffused with deep religious sentiment, such as *The Exodus*, pp. 16, 40, 42.

Seurat, Georges (Paris, 1859 – 1891), French artist who, with Signac, devised Pointillism. His painting *A Sunday afternoon on the Ile de la Grande Jatte* is seen as his manifesto, pp. 26, 27, 38.

Severini, Gino (Cortona, 1883 – Paris, 1966), Italian artist. He

■ Pablo Picasso, *The Lovers*, 1923, National Gallery of Art, Washington.

■ Auguste Rodin, *The Kiss*, 1836–98, Musée Rodin, Paris.

■ Gino Severini, *Large Still Life with Pumpkin*, 1919, Pinacoteca di Brera, Milan.

In 1899 he published *D'Eugène Delacroix au Néoimpressionisme*, where he expounded his theories of Divisionism, pp 26, 27, 28, 29, 38.

Skira, Albert, French publisher and founder of the eponymous publishing house in 1928 in Lausanne. Matisse illustrated a number of books for him, pp. 105, 118.

Stein, Gertrude (Allegheny City, Pennsylvania, 1874 – Neuilly-sur-Seine, Paris, 1946), American writer who, together with her brother Leo, was one of the first collectors of French avant-garde art, in particular Cubist works. Her acquaintance with Matisse, Picasso, and Braque led to the writing of *Three Lives*, published in 1930, pp. 41, 48.

Stein, Leo, brother of Gertrude. He lived with her in Paris until 1912. He shared with his sister a love of pictures and art, pp. 41, 48, 54.

Stein, Michael, brother of Leo and Gertrude Stein. He backed the Académie Matisse, pp. 52, 56.

Stein, Sarah, wife of Michael Stein, supporter of Matisse, pp. 52, 56, 57.

Shchukin, Sergei Ivanovich (1854 – Paris, 1936), important Russian collector who specialized in modern French works of art. Part of his collection is now in the Pushkin museum in Moscow and part is in the Hermitage in St Petersburg, pp. 54, 56, 56, 60, 61, 63, 64.

Tériade, Efstratios, French publisher, pp. 104, 118.

Vallotton, Félix (Lausanne, 1865 – Paris, 1925), Swiss painter and xylographic engraver who moved to Paris in 1882 and attended the Académie Julian. He linked up with the Nabis and devoted himself to xylography. Towards the end of his life he returned to painting, accentuating a realist character, pp. 17, 38, 103.

studied the works of Seurat and joined the Futurist movement in 1910. With *Maternity*, painted in 1916, he heralded the "return to order" proclaimed shortly afterwards throughout Europe, pp. 70, 99, 122.

Signac, Paul (Paris, 1863 – 1935), French artist who developed Pointillism with Seurat.

■ Paul Signac,
Guillaume Apollinaire on the banks of the Seine or L'île de la Grenouillère,
private collection.

■ Vincent van Gogh,
Self Portrait, 1889,
private collection.

1890), Dutch painter. In Paris in 1886 he discovered Impressionist art, studying Japanese prints, Gauguin, and Pointillism. His painting, pure energy both in treatment and color, described "the terrible passions of men". His life was often tormented, he suffered from depression and eventually committed suicide. He was an important source of inspiration for subsequent generations of artists, pp. 23, 24, 26, 38, 39, 41, 42, 50, 73.

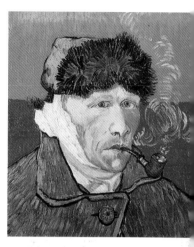

Valtat, Louis (Dieppe, 1869 – Paris, 1952), French artist who anticipated Fauvism in his use of pure color. Though never formally a member of the group, in 1905 he exhibited at the Salon d'Automne with Matisse and the other Fauves, provoking a sensation, pp.40, 48

Van Gogh, Vincent (Groot Zundert, 1853 – Auvers-sur-Oise,

Vlaminck, Maurice de (Paris, 1876 – Rueil-la-Gadelière, 1958) French artist who was perhaps the most forceful of the Fauvist group. He expressed himself with pure and shrill colors, which he applied directly to the canvas. After the end of World War I, he toned down his palette, adopting sombre colors, pp. 24, 40, 41.

Vollard, Ambroise, (Saint-Denis de-la-Réunion, 1867 – Paris, 1939), French art dealer who organized the first important Matisse exhibition in June 1904 in Paris, pp. 18, 23, 24, 25, 118.

Weill, Berthe, French art dealer. In 1902 she organized a show of paintings by some of Moreau's pupils in which Matisse took part, pp. 24, 46.

Zorah, one of Matisse's models. The artist painted her during his two trips to Tangier, pp. 65, 66.

■ Maurice de Vlaminck,
The Green House,
private collection.

A DK PUBLISHING BOOK
www.dk.com

TRANSLATOR
Fiona Wilde

DESIGN ASSISTANCE
Joanne Mitchell

MANAGING EDITOR
Anna Kruger

Series of monographs
edited by Stefano Peccatori and Stefano Zuffi

Text by Gabriele Crepaldi

The design of this book differs slightly from others
in the series in order to comply with conditions
required by the Estate "Les Héritiers Matisse".

© Estate of H. Matisse by SIAE 1998

PICTURE SOURCES
**Archivio Electa
Alinari - Giraudon**
Elemond Editori Associati wishes to thank all those museums and
photographic libraries who have kindly supplied pictures, and would be pleased
to hear from copyright holders in the event of uncredited picture sources.

Project created in conjunction with
La Biblioteca editrice s.r.l., Milan

First published in the United States in 1999 by DK Publishing Inc.
95 Madison Avenue, New York, New York 10016

ISBN 0-7894-4136-5
Library of Congress Catalog Card Number: 98-86755

First published in Great Britain in 1999
by Dorling Kindersley Limited,
9 Henrietta Street, London WC2E 8PS

A CIP catalogue record of this book is available from the British Library.

ISBN 0751307211

2 4 6 8 10 9 7 5 3 1

© 1998 Leonardo Arte s.r.l., Milan
Elemond Editori Associati
All rights reserved
© 1998 by SIAE

Printed by Elemond s.p.a. at Martellago (Venice)